HANDMADE HOLIDAY CARDS

from 20TH-CENTURY ARTISTS

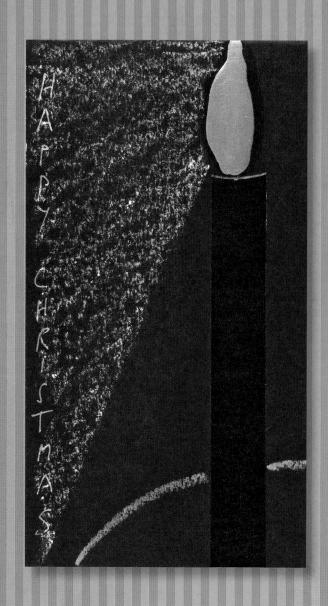

HANDMADE HOLIDAY CARDS

from 20TH-CENTURY ARTISTS

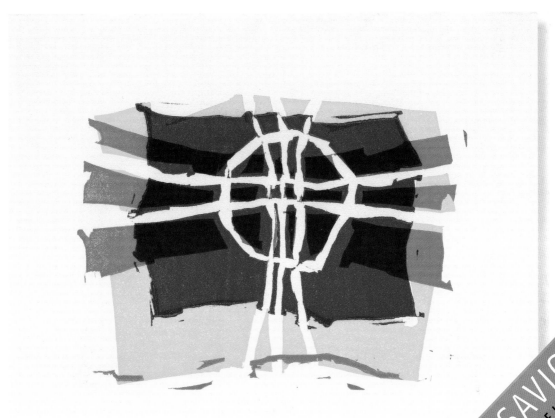

Smithsonian Books
Washington, DC

MARY SAVIG
FOREWORD by FAYTHE LEVINE

From the Collections
of the Smithsonian's
Archives of
American Art

p. ii **David Evison** to Piri Halasz,
ca. 2005
18 x 10 cm
fabric and metallic ink on paper
Piri Halasz papers, 1969–2009

Influenced by industrial landscapes and
modernist aesthetics, sculptor David Evison
(b. 1944) builds his abstract sculptures out of
steel and copper. Evison adapted his work
with metal to a holiday card with the silver
flame of a charcoal-hued candle. The gray glow
of the candle illuminates his Christmas
greetings to art critic Piri Halasz. Evison wrote
occasional reviews of art exhibitions for
Halasz's newsletter, "Report from the Front."

p. iii **Hale Woodruff**
to James Mullen, 1972
screen print
11 x 14 cm
James Mullen Christmas card
collection, ca.1955–2003
© Estate of Hale Woodruff

Together with Romare Bearden, Hale Woodruff
(1900–1980) formed a collective of African
American artists in 1963. They named this group
Spiral to acknowledge the diverse and fluid
aesthetics of black artists in the United States.
Spiral members met regularly in Bearden's
studio in New York City, where they grappled
with how to contribute to the Civil Rights
movement with contemporary black aesthetics.
Woodruff, a well-regarded painter and
printmaker, referenced his own interest in
cubism and African American symbolism in his
radiant 1972 holiday card to James Mullen.
On the interior of the card, Woodruff notes that
the title of his semi-abstract beacon of light
is *Primeval Image.*

p. v **Arturo Rodríguez** (b. 1956)
to Helen L. Kohen, undated
acrylic by Rodríguez on a postcard
of reproduction of *The Bedroom in Arles*
(1889) by Vincent Van Gogh.
10 x 15 cm
Helen L. Kohen papers, 1978–1996

This book may be purchased for educational, business, or sales promotional use.

For information, please write:
Special Markets Department
Smithsonian Books
P. O. Box 37012, MRC 513
Washington, DC 20013

Published by Smithsonian Books
www.smithsonianbooks.com

Director: Carolyn Gleason
Production Editor: Christina Wiginton
Edited by Jane McAllister and Lise Sajewski
Designed by Bill Anton | Service Station, LLC

Library of Congress
Cataloging-in-Publication Data

Savig, Mary.
Season's greetings : handmade holiday cards from twentieth-century artists /
[Mary Savig ; foreword by Faythe Levine].
 pages cm
ISBN 978-1-58834-330-7 (hardback)

1. Greeting cards—United States. 2. Art, American—20th century—Miscellanea.
3. Artists—United States—Miscellanea. 4. Archives of American Art. I. Title.

NC1860.S28 2012

745.594'120973—dc23 2012007104

Manufactured in China

16 15 14 13 12 5 4 3 2 1

CONTENTS

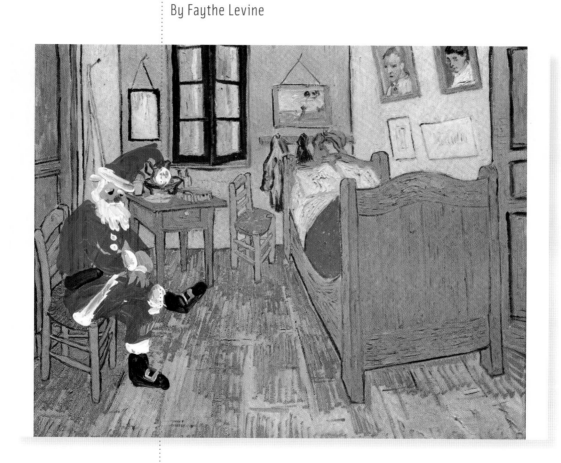

FOREWORD

THINKING ABOUT PROCESS, personality, and the importance of handmade runs through all facets of my day-to-day life. This attention to individual creativity started off early when I was born at home in the late 1970s to counterculture parents. An open-mindedness that included casual celebrations of both Hanukkah and Christmas are my earliest and strongest memories. As an only child with two parents working full-time, I loved the extra attention I received during the holidays, the time of year for making things: creating ornaments from homemade play dough, decorating wrapping paper with potato stamps, dousing glue-covered pinecones with glitter, spreading cotton-ball snow over construction-paper pine trees. And no California December would be complete without filling windows with hand-cut paper snowflakes to accentuate the sun and palm trees outside.

My father—a prolific writer—would spin an avant-garde version of the family update in a poem, giving homage to big changes, both personal and global, that happened throughout the year and imparting astrological foresight for the near future. The poems were lyrical, rhyming, and politically aware. My parents would then have a local printer produce a limited run of cards, paying close attention to the layout, design, and paper color. We sent each yearly edition to friends and family as the Levine family holiday card.

In our household we gave and received handmade cards for all occasions. I saved the most memorable cards handed down to me by my mother. The most treasured card is a copy of the hand-drawn and -lettered announcement of my birth, followed closely by my early birthday cards from family friends and poems my dad would write to me at summer camp. The painted, drawn, and inked papers drip with individual personality. I know only stories of many of the people who sent the cards, and these souvenirs of old family friends stay with me as an adult. The handmade cards are the ones that survived all these years. Their use of shapes and color palette give a nod to the popular aesthetic and design of the late 1970s. There is a sense of appreciation knowing someone took the time to make you something. I think most of us find it difficult to throw away a handmade memento.

It's amazing that I even have these cards with me today, because my small family moved around quite a bit. We started in Minneapolis, then spent an exciting year on the

Suzanne Levine hand-lettered the front of the card, announcing the birth of her daughter Faythe. The inside reads: "I have no name/ I am but two days old. What shall I call thee? I happy am/ Joy is my name. Sweet Joy befall thee! Pretty Joy! Sweet Joy but two days old, sweet joy I call thee; Thou dost smile/ I sing the while/ Sweet joy befall thee." – William Blake

Suzanne Levine for Faythe Levine, 1977
hand lettered ink on paper
21.6 x 28 cm

road traveling the country in the "Maroon Balloon" (that's what we called our van). We landed in Los Angeles in time for me to enroll in elementary school. At the tail end of the 1980s, we migrated to Seattle where I finished school.

As an adult I ended up coming back to the Midwest. For the past ten years my home has been in Milwaukee. Once people find out that I didn't grow up in Wisconsin, they want to know how I ended up here, and my answer always needs explanation. I came to visit a pen pal who lived in Milwaukee. After falling in love with the city, I decided to move. This explanation usually results in a confused facial expression that seems to say, "You moved to a city because of a pen pal?"

People are often surprised to hear that I've had easily hundreds of pen pals in my life. There is an obvious connection between having pen pals and being an only child who moved a lot, but bottom line—I really love connecting with people and always have. Letter writing was the way to connect back then. When I tell this story to younger friends who grew up with the Internet, they think it's wild. But I believe the mark of a human hand on paper triggers emotions that an email never could. It wasn't until I sat down to think about holiday cards for this book and their impact on my life that I realized mail has played a surprisingly large role in shaping who I am today.

I remember the first letter I received from a stranger, not from Grandma or Aunt Phyllis. I was attending elementary school in Los Angeles, and my class did a letter exchange with another school. The mystery of a letter from an unknown place, handwriting that belonged to someone else, the postage stamp, and the postmark with the date—I was hooked. From that point on, I took any and every opportunity to get and send mail.

My immediate fixation with correspondence mixed with early artistic tendencies nurtured by my parents and developed into a lifelong addiction. What would now be deemed as "mail art" became my obsession during high school. It was the perfect combination of my three main loves: hand lettering, collage, and photography. The people whom I corresponded with lived both surprisingly near and also very far. The height of my mail writing was during the early 1990s. I was meeting like-minded people through the underground music scene in the Northwest. The DIY (do it yourself) music community was directly linked with the underground music and zine culture (zines are photocopied, self-published magazines) popular at that time. The early '90s were pre-Internet, and it was common to write letters to people you had never met but whose names and addresses were listed in the zines, records, and cassette tapes that you could buy at shows. A network of creative people around the globe struck up friendships through the mail to share their

Evan Ross Murphy to Faythe Levine, 2004
mixed media
15.2 x 26.7 cm (folded)

I met artist Evan Ross Murphy when we lived in Milwaukee in the building known as The Fortress. When I turned 27 in 2004, I found this card slipped under my door. Inside the card, in pencil, the greeting reads, "Faythe, Happy Birthday or whatever. Love Evan Ross Murphy." Evan now lives and works in Los Angeles, California, building sets and landscaping an amazing cactus garden in his yard.

counterculture interests. Many of us remain friends to this day.

During that time, a lot of the mail actually said very little; the elaborately decorated envelopes and beautiful artistic contents spoke loudly. You could spend hours crafting a single piece of very delicate mail. We all tried to outdo one another and see what we could send: slabs of wood, recycled packaging that to the untrained eye resembled trash, all manner of paste, glue, and paper. Sending off unusual materials involved an element of risk—you could only hope your mail would reach its destination.

Over time I lost touch with a lot of these friends, but years later social media websites brought many of them back into my life. It was not surprising to find many of them working in creative jobs: graphic designers, illustrators, musicians, clothing and jewelry designers, filmmakers, photographers. We rekindled our relationships on a professional plane and began to work together, with a foundation of more than twenty years of letter writing at the root of our acquaintance.

In 2003 I made the blind leap to become a full-time working artist, inspired in part by my creative peers. My roots in the DIY community gave me the courage and work ethic to join the forefront of this exciting time for young, creative entrepreneurs taking advantage of new online markets and communities. I quickly established myself as a designer and started my company Flying Fish Design that featured a small line of objects produced in-house: wearable textiles, plush toys, jewelry, and of course, a stationery line.

Matthew Himes to Faythe Levine, undated
mixed media collage with hand stitching
19 x 11.4 cm

Through Flying Fish I became invested in this newfound creative community, made accessible through the word "craft," and met many others whose stories follow a similar path. I devoted myself entirely to making, creating, sharing, and connecting with other makers, and to educating the public on the importance of art. Over the course of a short time, I met influential artists whose visionary ways changed how I look at the world. My home is filled with mementos—cards, paintings, clothing, art objects—my love for the mark of one's personal touch runs deep.

I believe in the "no rules" ethos embraced by the DIY community and encourage people to dive in headfirst. My agenda will always include promoting the liberating ethics of a DIY lifestyle into mainstream culture, because people often need a permission giver. But I also have developed a deep respect for tradition. Training, dedication to a single process, and craft guilds maintain a certain level of quality that I now find equally as important as the haphazardness of my youth. Personally I'd like to find a balance between the two.

I have spent the past ten years of my life immersed in the youthful resurgence of craft paralleled by overwhelming access to information. Increased dialog about sourcing

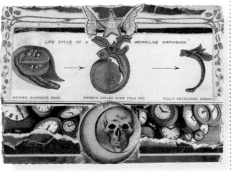

Matthew Himes to Faythe Levine, undated
mixed media collage
14.6 x 10 cm

When we both lived in Minneapolis, Matthew Himes and I started sending mail to one another to make small beautiful things and exchange art. I have over thirty striking pieces I kept from that time. These two postcards are a couple of my favorites. Matthew, also a musician, now runs a small record label, Lighten Up Sounds, that releases very limited editions of experimental cassette tapes and records. We still occasionally send each other mail.

materials from green sources has moved to the forefront in conversation. With the continuing stream of information available, both maker and consumers can educate themselves. Handmade has a wide reach of new possibilities at everyone's fingertips, generating an exciting, positive buzz.

The "how-to" online tutorials have proliferated and motivated many people. Hands-on processes empower beginner craftspeople to make art themselves and save money using recycled materials. And as people become more familiar with process, they learn why certain techniques or materials cost more. So, if they don't make their own silkscreen cards for Christmas, they know why it's worth spending the extra money to buy unique, small-run, artist-made cards. Finding local brick-and-mortar shops that support independent artists is one way to support artist-made goods. And taking advantage of powerful search engines on user-friendly online shops like Etsy.com is a sure-fire way to discover more amazing handmade work.

After I first looked through the rich collection of handmade cards in this book, it felt like a nudge in the side about the importance of personality. Even as someone who thinks about handmade daily, I must admit that, when pinched for time in the past few years, I have found myself sending birthday text messages or posting congratulations on Facebook. This book should be a reminder that access to information about and exposure to artist-made goods should further the tradition of sending handmade cards. We must remind ourselves to use the computer as a tool, not a replacement for our personality.

I think about my personal experience—the romantic and laborious process I went through as a teenager—cutting, pasting, tweaking my cards to perfect imperfection. If I only had the time again…then I remember it's the small, easy choices that can make a big impression. The memories we build by creating and giving art have lifelong impact. Often it takes just one piece of work to trigger inspiration. I am moved by how strongly people's personalities come through in their cards, specifically through their handwriting and choice of design. *Handmade Holiday Cards by 20th-Century Artists* gives the reader a voyeuristic thrill of reading someone's private mail. This book contains the perfect diverse collection of cards to provide the inspiration to revisit your own collection of cards tucked away in a shoebox. Perhaps you haven't unpacked the cards in a few years? Take them out and share, revisit the people and memories they contain. Let's all make a pact to celebrate future holiday seasons by continuing the tradition of giving something with meaning.

Faythe Levine

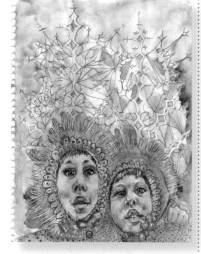

Micaela O'Herlihy for Faythe Levine
and Kim Kisiolek, 2007
pencil and gouache
16.5 x 22.9 centimeters

Micaela O'Herlihy is a good friend and an amazingly talented artist. She was the director of photography of my first film, *Handmade Nation*, and I have shown her fine art in my gallery a number of times. In 2007 Kim Kisiolek, my business partner at Paper Boat Gallery, and I commissioned Micaela to paint a holiday card for the gallery. The original artwork is in pencil and gouache. The image was reproduced as a 4 x 6 offset printed postcard in an edition of 250 and sent to our mailing list of artists and clients.

AT FIRST GLANCE NELL PERRET'S ETCHING (fig. 1) describes any New York gallery opening: well-heeled art enthusiasts huddle together with their shoulders back and heads raised in contemplation. But they are not studying avant-garde paintings. Their intense conversation takes place in front of, and presumably revolves around, a string of holiday cards. Perret's image elevates the humble status of the holiday card into the sophisticated realm of the art world.

Every December seasonally inspired works of art are pinned to strings, prominently displayed on mantelpieces, or taped to doors in the pyramidal shapes of Christmas trees. The holiday-card market in the United States has always been infused with the notion that holiday cards are art for the masses. When Louis Prang introduced the first holiday cards to an American audience in 1875, he shrewdly sold them on the premise that they were affordable artworks. In his Boston printing shop, Prang perfected the recently invented chromolithography printing process, allowing him to publish high-quality reproductions of artworks in large quantities. In just a few short years, L. Prang & Co. shaped the exchange of holiday cards, which had previously been limited to wealthy Americans who could import cards from London, into a thriving national tradition. By 1880 the company was publishing more than five million holiday cards annually. Competitors rushed to get a slice of the market.

To keep ahead of his competitors, in 1880 Prang initiated a series of yearly design competitions to lure talented artists with sizable cash awards. Two years later the *Boston Daily Globe* lauded the winning designs for that year: "All full of the joy and happiness of Christmas time and most artistically executed. Prang & Co. do a real service to art in the attention they pay to making so beautiful and artistic these cards, such multitudes of which find their way all over the country and into the homes of every degree." To further emphasize the artistic merits of Prang cards, the company staged annual exhibitions at the American Art Gallery in New York City to display the design submissions. Among the winners of Prang's competitions over the years were painters Thomas Moran, Elihu Vedder, and J. Alden Weir.

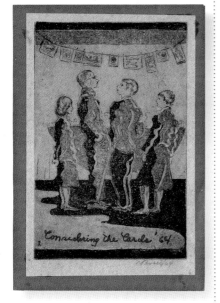

Fig. 1 **Nell Perret** (1916–1986)
to George Constant, 1964
intaglio print
13 x 10 cm
George Constant papers, 1912–2007

Trying to outdo one another, Prang and his competitors trimmed their colorful cards with velvet ribbon, crystal flitters, or even satin fringe. Such fads came and went, but the public continued to hold color lithographs in high esteem. The growing industry catered to the personal wants of the public through expanded subject choices and options for personalization. When L. Prang & Co. lost its footing in the market, others—including American Greetings Corporation, founded in 1906, and Hall Brothers, Inc., founded in 1915 and later known as Hallmark—flourished in its place. In 1925 the *Wall Street Journal* reported that more than one billion cards changed hands that year. Prang's vision of using holiday cards as art for the masses endured. In 1949, for example, Hallmark staged its own competition, and a jury selected one hundred winning designs for exhibition at the Wildenstein Galleries in New York City. Hallmark had wisely portrayed itself as in sync with the art world's trends.

In the first half of the twentieth century, artists remained integral to this booming social custom. Indeed, the holiday-card business had become so lucrative that many artists tapped into the market to promote their art. In 1934 dozens of artists formed the American Artists Group (AAG) to popularize American art by selling original designs on holiday cards, which also served to provide the artists with much-needed income during the Great Depression. The designs the AAG published were as varied as the artists, but they all fulfilled the buyers' desire to share art. In 1948, when approximately 1.5 billion cards were exchanged, the AAG sold a full line of cards in frames, ready for hanging on the walls of American homes. The gimmick gave everyday Americans the thrill of collecting and curating their own art acquisitions. Artists, too, were happy to have their works displayed in the homes of consumers.

Museums also entered into the holiday-card trade. The Metropolitan Museum of Art in New York City and the National Gallery of Art in Washington, D.C., carved their niches in the market with reproductions of old master paintings of biblical scenes, still lifes, and landscapes. Beginning in 1954 the Museum of Modern Art (MoMA) recruited vanguard artists such as Alexander Calder and Paul Klee to bring contemporary flair to the holiday season. One of the first iterations of Robert Indiana's most publicly adored subjects, the "LOVE" motif, was a card sold by MoMA in 1965. For his holiday card of 1964, Indiana had made pencil rubbings of the word LOVE, complete with his signature slanted *O* (fig. 2); one recipient of his card was MoMA curator Dorothy Miller. The following year MoMA commissioned from Indiana a more-colorful take on the original design for its holiday-card line.

Some artists ventured into the market on their own, making small batches of cards for sale. Cape Cod painter Peter Hunt's line of screen-printed holiday cards (fig. 3

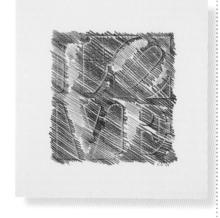

Fig. 2 **Robert Indiana** (b. 1928)
to Dorothy Miller, 1964
pencil rubbing on paper
21 x 21 cm
Dorothy C. Miller papers, ca. 1912–1992
© 2012 Morgan Art Foundation /
Artists Rights Society (ARS), New York

Robert Indiana's "LOVE" motif originated as a holiday card and then exploded in popularity: in 1966, Stable Gallery devoted an entire exhibition to the LOVE paintings. Today large-scale LOVE sculptures are found in numerous cities throughout the world.

and p. 112) featured a distinct style contrived from European and Pennsylvania Dutch folk art. Hunt himself was neither European nor Pennsylvania Dutch—he grew up in a tenement in New Jersey—but his folksy aesthetic was popular along the East Coast. In the early 1950s, Frederick Hammersley began a short-lived greeting-card company, Handsome Press. Hammersley infused his cool modern aesthetic with holiday whimsy on screen-printed cards (fig. 4 and pp. 38–39).

The holiday-card industry expanded in tandem with an American society that was becoming increasingly driven by individualism. In 1949 more than twenty-five thousand different designs were packaged and sold in department and specialty stores, and by 1961 that number had doubled. Senders carefully selected cards they thought would best represent their personalities and make positive impressions on the recipients. The sharing of cards was not simply modeled on the goodwill between friends and family but rather, situated one's social standing. Well-chosen cards communicated a family's happiness to acquaintances or demonstrated a businessperson's appreciation for the boss. A successful card would stand out from its neighbors on the fireplace mantle.

The stakes were higher for artists than for the purchasers of cards: an artist's holiday card had to top the extremely imaginative cards that were circulating in the commercial market. Many artists chose to subvert commerce and make holiday cards that asserted their individuality. The Smithsonian's Archives of American Art has in its collections several hundred handmade holiday cards. Whether they are whimsical watercolors or quirky collages, they offer insight into how artists have imagined the holidays, shed light on how artists formulated new relationships and strengthened old, and reflect the circumstances under which the artists created them. Collectively these holiday cards reveal the personal sides of artists.

Fig. 3 **Peter Hunt** (1896–1967),
unsent, ca. 1940
screen print
13 x 19 cm
Peter Hunt papers, 1788–1968

Fig. 4 **Frederick Hammersley** (1919–2009),
unsent, ca. 1955
screen print
13 x 10 cm
Frederick Hammersley papers, 1897–2008

The cards featured in this book are as diverse and deep as American art itself. Their creators range from painter of the American West Allen Tupper True (fig. 5) to ex-con folk artist Henry Ray Clark, best known as the Magnificent Pretty Boy (fig. 6). Each card boasts of its maker's personal and artistic life. True's prototype of a holiday card sent to his daughter Jane for approval is a visual metaphor of the artist's imagination. With a brush between his teeth and a palette in his hand, the dapper painter works among the clouds and a starry sky. Clark, who was imprisoned on numerous occasions, traveled beyond the night sky in his dreams; while incarcerated, the self-taught artist drew intricate, prismatic abstractions on any scrap of paper he could find. The *Houston Chronicle* quoted Clark on his approach to art: "If anybody knows anything about my art, they know about my planets and I know they are out there because I've been there. Every night when I go to bed, I travel in my spaceship going to all the places I put on these papers." Clark's postcard to folk art collectors Chuck and Jan Rosenak features Clark proudly posing in front of his Houston home. Not one to be modest, Clark formed the initials of his nickname (MPB) on his fence with a string of lights.

Holiday cards have given photographers an opportunity to turn their cameras on themselves. Nickolas Muray, who was often in high demand by magazines and advertising agencies for his stunning photographs of celebrities, politicians, and models, posed as a musical angel with fellow photographer Ruzzie Green for his card in 1937 (fig. 7 and pp. 64–65). Muray and Green collaborated frequently on their over-the-top cards, playing the roles of gladiators, Santa Claus, and Father Time. Muray's later cards featured his photographs of his two children.

Holiday cards frequently reveal events of an artist's life. Painter Charles Burchfield, best known for his lyrical watercolor evocations of nature, wrote an illustrated card to his sister Louise just before Christmas 1933 (fig. 8). That holiday season was difficult for the Burchfields. Earlier that year, on June 13, their sister Frances died; ten days later, on June 23, their mother passed away. Burchfield writes inside the card, "I wish I could comfort you during this time. It was hard before, but now it gets progressively harder as Christmas approaches. I'm sure that Mother and Frances would want us to be happy, if we could, so I suppose we ought to try." The red cone of a sumac pod and milkweed seeds descending are perhaps signs that even in death, life goes on.

Philip Guston's holiday cards illustrate a shift that occurred late in his career. Guston, who was associated with the Abstract Expressionist movement, took up figure painting after 1966. Living in relative seclusion in Woodstock, New York, Guston began

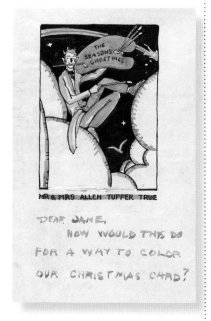

Fig. 5 **Allen Tupper True** (1881–1955)
to Jane True, ca. 1937
watercolor on paper
22 x 14 cm
Allen Tupper True and
True family papers, 1841–1987

Given his background in commercial illustration, True, like many artists in the early twentieth century, was inclined to make holiday cards. Before he earned recognition for his paintings and murals of the Rocky Mountains, True sought illustration jobs.

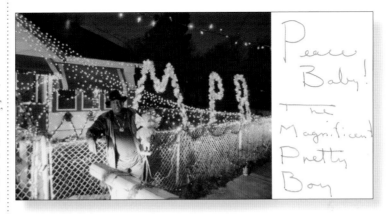

Fig. 6 **Henry Ray Clark,**
"The Magnificent Pretty Boy"
(1936–2006)
to Chuck and Jan Rosenak, ca. 2000
photograph
9 x 17 cm
Chuck and Jan Rosenak research
material, ca. 1987–1998

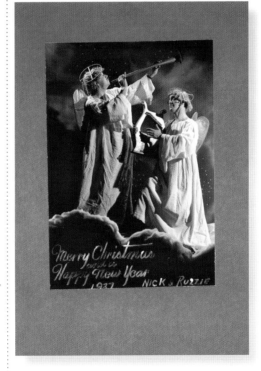

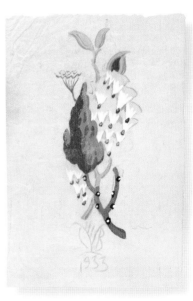

Fig. 7 **Nickolas Muray** (1892–1965),
unsent, 1937
photographs adhered to paper
23 x 16 cm
Nickolas Muray papers, 1911–1978
© Nickolas Muray Photo Archives

Fig. 8 **Charles Burchfield** (1893–1967)
to Louise Burchfield, 1933
watercolor on paper
16 x 11 cm
Reproduced with permission of
the Charles E. Burchfield Foundation

Burchfield embellished the front of the card with a watercolor that he called a "souvenir of my winter bouquet picture..." He explained, "First I made a wood-cut of my studio as a greeting but it looked so much like an early [J. J.] Lankes that I had to abandon it. I think this is more Burchfieldesque." By "souvenir," he meant that he painted it from the same still life in his studio window that he had used for his painting *Winter Bouquet*, 1933 (Museum of Fine Arts ,Boston).

sketching small objects scattered throughout his studio, such as an open book or a pen and its inkwell. In a holiday watercolor to Elise Asher from the early 1970s (fig. 9; and p. 48), Guston depicted a teakettle warming by a fire. Despite their inherent simplicity, the drawings and paintings the artist made after 1966 evoke a sense of gravitas. Critics first admonished Guston for his change in style and then embraced it.

Holiday cards are often a sign of the times, especially when a particular historical moment had a great impact on an artist. Like many of his American compatriots, Ralph Fabri (fig. 10; and p. 156) endured both the Great Depression and World War II. During the Depression the Hungarian-born artist temporarily had to suspend his pursuit of portraiture to establish a commercial studio. He pieced together his living by designing window displays for retailers and stage sets for theatrical productions. In 1939, during the throes of World War II, he created a holiday card that made clear his grim view of the world: a contemplative Santa Claus, styled after Auguste Rodin's masterpiece *The Thinker*, 1902 (Musée Rodin, Paris), watches the entire planet burn in flames. As a wry nod to his own vulnerable status as an artist, Fabri added in a caption, "With apologies to Rodin."

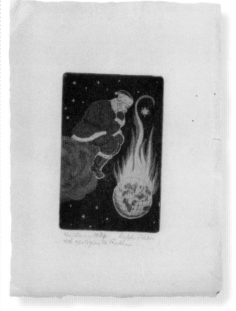

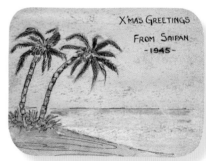

Fig. 9 **Philip Guston** (1913–1980)
to Elise Asher, ca. 1972
watercolor on paper
13 x 18 cm
Elise Asher papers, 1923–1994

Fig. 10 **Ralph Fabri** (1894–1975)
to Dale Pontius, 1939
intaglio print
22 x 16 cm
Dale Pontius papers relating
to Ralph Fabri, 1935–1974

Fig. 11 **Dimitri Hadzi** (1921–2006)
to his parents, 1945
watercolor on paper
8 x 11 cm
Dimitri Hadzi papers, 1943–2003

Many artists served in the military during World War II. Dimitri Hadzi, the son of Greek immigrants, volunteered for service in 1942. As a radio mechanic in the South Pacific with the Fifth and Twentieth Air Force, he spent much of his time drawing, an activity encouraged by one of his superiors. In 1945, Hadzi enclosed a small card with a letter home to his mother and father (fig. 11). The exotic palm trees and idyllic beach likely ameliorated the worry that his parents felt for their son. After the war Hadzi enrolled in courses at New York City's Cooper Union for the Advancement of Science and Art and earned recognition, including a Fulbright fellowship, for his semiabstract sculptures of wood and metal.

A consequence of the two world wars was the influx of émigrés to the United States from Europe. Artists and their families fled the Continent if they were Jewish or active in artistic movements deemed "degenerate" by Hitler. The migration of modern artists effectively shifted the center of the art world from Paris to New York City. American painter Kay Sage (fig. 12; and p. 54) met her future husband, French painter Yves Tanguy, in Surrealist circles in Paris. As tensions in Europe mounted, the couple decided to move to the States. They collaborated on their annual holiday cards until Tanguy's sudden death in 1955.

Not all artists felt welcome in the United States. As an African American woman, Loïs Mailou Jones regularly faced blatant racism from her fellow Americans. In 1937 she took her first of many trips to the more racially tolerant Paris, where she relished being judged for the qualities of her art rather than her race or gender. Jones's holiday greeting to an American colleague in Paris, art dealer Martin Birnbaum, unites her two worlds: her Boston roots—and her love of Boston terriers—and her second home in the City of Lights (fig. 13).

Fig. 12 Kay Sage (1898–1963) to Eleanor Howland Bunce, 1962 paper clip, rubber band, and cardboard 4.5 x 15 cm Eleanor Howland Bunce papers, 1935–1982

Sage struggled immensely with the death of her husband, Yves Tanguy, in 1955, but she continued with her holiday-card tradition. Her solo "cards," are some of the most unusual in the collections of the Archives of American Art. In January 1963, weeks after making the artwork shown here, the bereaved Sage took her life.

Of all the subjects depicted on holiday cards in the Archives of American Art's holdings—with images running the gamut, from Boston terriers to palm trees to jolly Saint Nicks—symbols of Hanukkah are relatively rare. The Jewish artists represented in this book shied away from religious motifs. Their choice of secular topics paralleled the commercial market. While some companies sold Hanukkah cards throughout the twentieth century, those sales were a mere fraction of the market. Hanukkah itself was not nearly as commercialized as Christmas until the 1980s, when products like cards, wrapping paper, and decorations became more widely available. In the early 1970s, painter Moses Soyer sent an illustrated letter to his grandson Daniel about Hanukkah (fig. 14). The Santa Claus graphic hardly needed an explanation, but Soyer described Hannukah as a "gay and pretty holiday" and continued, "People who celebrate it light each day a candle for 7 days so that at the end of Chanuka all candles are lit." Soyer signed his charming letter with little portraits of himself and his wife, Ida, and their dog, Martha. Whether an artist's subject matter was religious, secular, political, or humorous, he or she represented the holidays in ways that felt comfortable.

A midcentury influx of artists who moved from Asia and Latin America to the United States added their own cultural influences to increasingly global art communities. Unichi Hiratsuka came from Japan to join the flourishing community of printmakers in

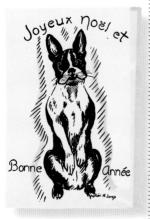

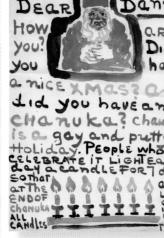

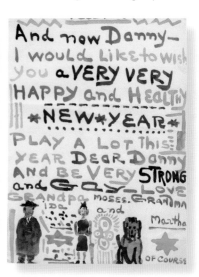

Fig. 13 **Loïs Mailou Jones** (1905–1998)
to Martin Birnbaum, ca. 1937
hand-colored print
18 x 12.5 cm
Martin Birnbaum papers, 1862–1970

Fig. 14 **Moses Soyer** (1899–1974)
to Daniel Soyer, ca. 1970
watercolor on paper
25 x 27 cm
Moses Soyer papers, ca. 1905–1974

Washington, D.C., led by Prentiss Taylor and Jacob Kainen. In his holiday print from 1973 (fig. 15; and p. 21), Hiratsuka shared with his recipients a familiar sight in Asia, Japanese lantern plants. The groupings of holiday cards that Washington artists such as Taylor and Kainen saved articulate the large network of artists who traveled through that city in the latter half of the twentieth century. Washington-based artists may not have corresponded, given their close proximity, but their holiday cards are a physical trace of their relationships. The holiday cards in the Archives of American Art's collections help map friendships formed in the art world.

New York artists working between the bohemian enclaves of Greenwich Village and Woodstock art colonies exchanged copious cards. Konrad and Florence Ballin Cramer maintained a thickly bound scrapbook that showcased the spirited cards they received for more than thirty years (fig. 16; and pp. 63 and 67). In 1928, for example, they saved a card by potter Carl Walters of a speckled creature. Walters was known for his chimerical ceramic sculptures of animals. In an ink sketch, sculptor Eugenie Gershoy humorously depicted herself resting in bed as her husband, artist Harry Gottlieb, juggled a variety of chores and art projects. Aileen Webster mailed a small print of her petite brownstone beaming Christmas greetings over New York City's skyline. Annual holiday cards like these marked enduring friendships in close-knit artist communities.

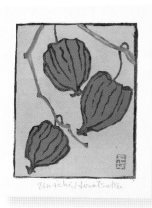

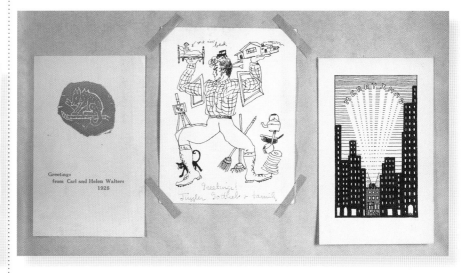

Fig. 15 **Unichi Hiratsuka** (1895–1997)
to Jacob Kainen, 1973
relief print
17 x 14 cm
Jacob Kainen papers, 1905–2003

Fig. 16 **Konrad and Florence Ballin Cramer,**
holiday card scrapbook, 1920–1950
bound volume of holiday cards adhered
to album pages
27 x 25 cm
Konrad and Florence Ballin Cramer papers,
1897–1968

Individual cards from left to right:

Carl Walters (1883–1955), 1928; relief print, 13 x 8 cm

Eugenie Gershoy (1901–1986) and **Harry Gottlieb** (1895–1993), 1928; photomechanical reproduction of a drawing, 12.5 x 10 cm

Aileen Webster, 1928; hand-colored print, 13.5 x 8.5 cm

Artists also forged and maintained relationships with institutions through holiday greetings. Museum curators Dorothy Miller and Samuel Wagstaff received a great number of cards over the years, suggesting their close relationships with artists. Art dealers also received cards from the loyal artists they represented. In the early 1990s, Mike Bidlo sent a curious card to his dealer, Leo Castelli (fig. 17). Bidlo's body of work reads like a mischievous textbook of art history. With facetious titles such as *Not Duchamp* and *Not Pollock*, he replicated the masterpieces of Marcel Duchamp, Pablo Picasso, Jackson Pollock, and other notable artists. When Bidlo sent this holiday card to Castelli, he was referencing the work of another star of appropriation represented at Castelli's gallery, Andy Warhol. Warhol's *Brillo Boxes*, 1964, imitated the design by James Harvey for the Brillo brand's soap pads, a product that lined grocery-store shelves across the nation. To wish Castelli a Merry Christmas, Bidlo personalized a used cardboard Brillo box with a handprint in black paint.

Holiday-card networks also took root at universities. James Mullen began making cards as an undergraduate at the Pennsylvania State University and carried the tradition to the State University of New York at Oneonta, where he began teaching art in 1963. Like his paintings, his holiday cards are often poignant still lifes. The card he made in 1991 (fig. 18) neatly pays tribute to small holiday rituals that ought to be cherished, such as enjoying a cup of tea and a gingerbread cookie. Portraying simplicity was anything but a simple task for Mullen: he made several linocut prints before he perfected this serene tableau.

One of the largest accumulations of holiday cards held by the Archives of American Art belongs to Kathleen Blackshear and Ethel Spears (fig. 19). The two artists met and fell in love while teaching art at the School of the Art Institute of Chicago, where they each steered the fledgling careers of generations of young artists. For decades Blackshear and Spears annually received a flurry of cards from artists who had passed through the Art Institute at some point in their careers. Among the women's friends were former and current students, fellow colleagues, and even nuns. Painter Julia Thecla (fig. 20; and p. 123) sent the women her twist on a cherub in Raphael's painting of around 1513–1514, *Sistine Madonna* (Gemäldegalerie Alte Meister, Dresden, Germany). Indulging in vice, Thecla's cherub puffs a cigarette and has already finished off a bottle of wine.

With ever-growing holiday-card lists, artists put a great deal of energy into making cards in time for Christmas. When Andrew Bucci began sending cards in the 1950s, he screen printed and mailed about fifty cards. His festive designs eventually proved so popular that he could no longer meet the demands of his friends using his laborious

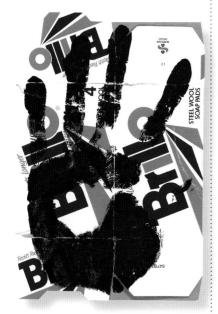

Fig. 17 **Michael Bidlo** (b. 1953)
to Leo Castelli, ca. 1990
acrylic on a Brillo box
21 x 15 cm
Leo Castelli Gallery records,
ca. 1880–2000

As he had done in this card made around 1990 for gallery owner Leo Castelli, Bidlo paid homage to Andy Warhol by replicating Warhol's *Brillo Boxes* of 1964 with his piece *Not Warhol (Brillo Boxes, 1964)* of 2005. Both artists aimed to stop viewers in their tracks, inciting questions about the role of art in culture and commerce.

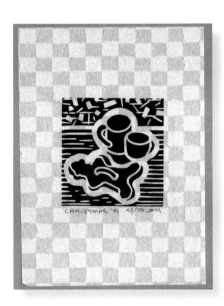

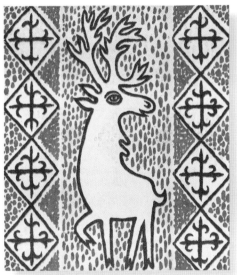

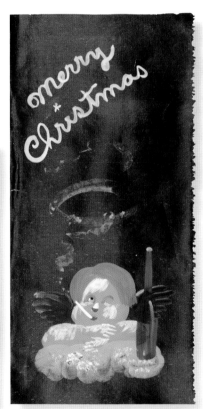

Fig. 18 **James Mullen** (b. 1935),
unsent, 1991
relief print
16 x 12 cm
James Mullen Christmas card collection,
ca. 1955–2003

Fig. 19 **Kathleen Blackshear** (1897–1988),
to Andrew Bucci, 1964
screen print
22.5 x 19.5 cm
Andrew Bucci papers, 1947–1985

Fig. 20 **Julia Thecla** (1896–1973)
to Kathleen Blackshear and
Ethel Spears, undated
acrylic on metallic paper
17 x 8 cm
Kathleen Blackshear and
Ethel Spears papers, 1920–1990

printing process. Surprisingly, Bucci found it easier and faster to draw and paint every single card (fig. 21; and p. 191), which numbered about 125 at the peak of his production. Among his recipients were Blackshear, Spears, Prentiss Taylor, and pioneer of the Minimalist movement, Dan Flavin. In response to Bucci's good wishes, Flavin mailed him a minimalist collage consisting of a single sticker and a stamp (fig. 22), materials more common in office-supply cabinets than artists' studios. Flavin had always pushed the envelope with his materials, defying convention and earning him a revered spot in art historical canons, but when Bucci reflected on his old friend's Christmas card, he chuckled and jokingly said, "Dan was just lazy!"

The handmade artworks in the collections of the Archives of American Art surpass definitions of holiday cards. The simple sentiments expressed by exceedingly creative hands relay how art functions to challenge the status quo and inspire originality. Artists contributed to the advancements of the holiday-card trade and then pushed back by creating exceptionally engaging, one-of-a-kind cards for their friends, family, and associates. In small-scale artworks rarely intended for exhibition or sale, they articulated their artistic idioms through intimate messages of cheer and love, making their works all the more stimulating. The artists represented in the Archives, whose works are illustrated in these pages, succeed in evoking the romance, humor, peace, and joy of the holiday season with the ingenuity of their handmade cards.

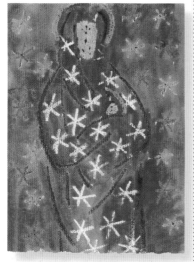

Fig. 21 **Andrew Bucci** (b. 1922)
to Kathleen Blackshear
and Ethel Spears, 1957
colored pencil and watercolor on paper
16 x 12 cm
Kathleen Blackshear and
Ethel Spears papers, 1920–1990

Fig. 22 **Dan Flavin** (1933–1996)
to Andrew A. Bucci, 1963
stamp and sticker on paper
10 x 12.5 cm
Andrew Bucci papers, 1947–1985
© Stephen Flavin/
Artists Rights Society (ARS), New York

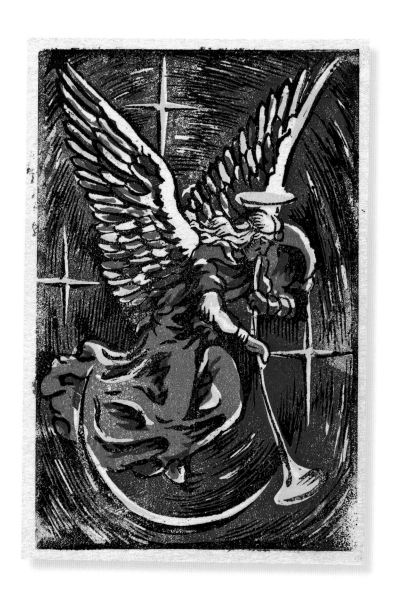

Carson Davenport to Prentiss Taylor, 1960
relief print
18 x 12 cm
Prentiss Taylor papers, 1885–1991

Carson Davenport (1908–1972) strove to make art that simulated the radiance of stained glass. He had an early success as a young artist employed by the New Deal's Public Works of Art Project during the Great Depression. One of his paintings caught the eye of First Lady Eleanor Roosevelt, who selected it to adorn a room in the White House. Davenport later became an art educator in his home state of Virginia, where he painted dazzling landscapes of the coast. The loud, jewel-like colors of his holiday card of 1960 to printmaker Prentiss Taylor conjure the music sounding from the angel's horn.

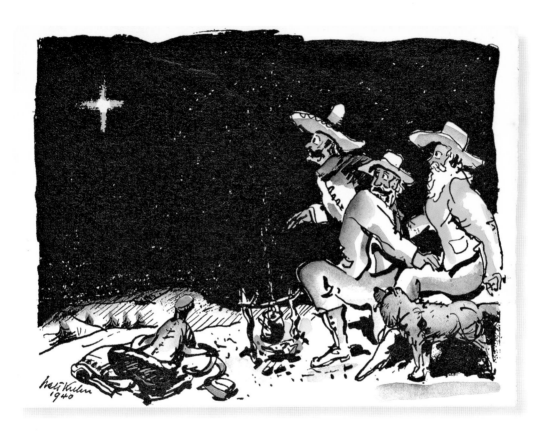

Walt Kuhn to Alfred Frueh, 1940
hand-colored print
15 x 20 cm
Alfred J. Frueh papers, 1904–1993

Modern art advocate and painter Walt Kuhn (1877–1949) founded the Penguin Club in 1917. The dynamic group—which included this card's recipient, cartoonist Alfred Frueh—united New York artists who were interested in gathering and discussing the art of their time. Club members staged meetings, exhibitions, and raucous dances and festivals, among them a notorious annual gala that required guests to arrive elaborately costumed. For his card made in 1940, Kuhn reimagines the Three Wise Men, described in the Bible as "from the East," as awestruck cowboys from America's Wild West.

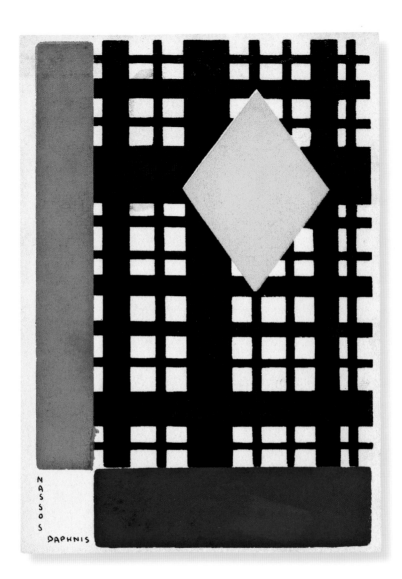

Nassos Daphnis to George Constant,
ca. 1965
screen print
17.5 x 12.5 cm
George Constant papers, 1912–2007
© 2012 Nassos Daphnis/Artists Rights
Society (ARS), New York

After immigrating to the United States from Greece when he was sixteen, Nassos Daphnis (1914–2010) did not return to his home country until around 1950, on a trip to Europe courtesy of the GI Bill. In an oral history interview with the Smithsonian Institution's Archives of American Art in 1968, Daphnis explained how the remarkable Greek landscape changed his outlook on art. "I would see everything flat," he said. "For instance, you would just see a house as a house but not as little stones put together; the whole thing was one form with nothing in between. From then on I eliminated all the textures on my painting and started painting flat." Daphnis applied those perceptions to his holiday card to fellow Greek American artist George Constant.

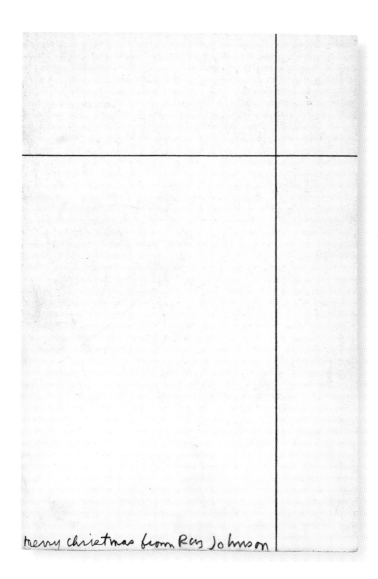

merry christmas from Ray Johnson

Most artists sent only holiday cards through the postal system, but Ray Johnson (1927–1995) mailed much of his art. As a prominent figure in the mail art movement of the 1960s, Johnson created envelope-friendly collages and letters that he dispatched to friends, curators, and even individuals he did not know. Johnson reveled in metaphorical motifs, and his crafty sense of humor often perplexed and delighted the recipients of his works. His holiday card to fellow East Village artist Helen DeMott seems to be a straightforward sketch of a cross, but its intriguing use of Christian symbolism instigates more questions than it answers.

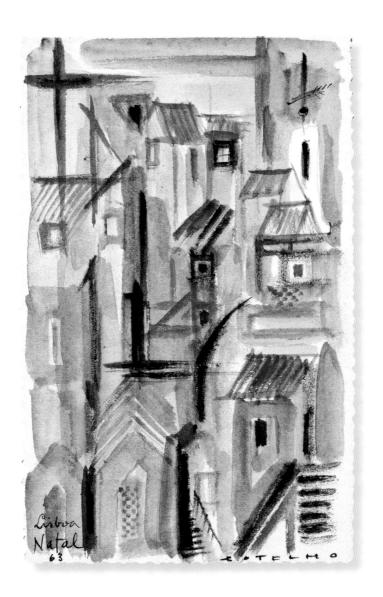

Carlos Botelho to Harold Weston, 1963
watercolor on paper
15 x 10 cm
Harold Weston papers, 1894–1978

Globe-trotting modernist painter Harold Weston received good tidings from friends all over the world. Portuguese artist Carlos Botelho (1899–1982) sent Weston this expressive watercolor of the rooftops of a neighborhood in Lisbon. Below the sketch, he wrote, in Portuguese, "Lisbon Natal," or "Lisbon Christmas."

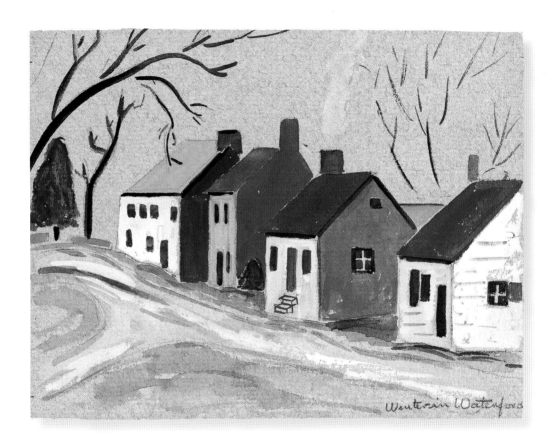

Jane Hays Jones to Eugenie Gershoy, 1956
gouache on paper
12 x 16 cm
Eugenie Gershoy papers, 1914–1983

Painters Wendell Jones and Jane Hays fell in love in 1928 while summering in Woodstock, New York. They married in 1931 and resided permanently in Woodstock until Wendell's death in 1956, the year Jane made this card for sculptor Eugenie Gershoy. In a lengthy note inside the card, Jane writes of a recent trip she took through the snow-covered Catskills. On the front of the card, she painted a quiescent neighborhood in Waterford, New York.

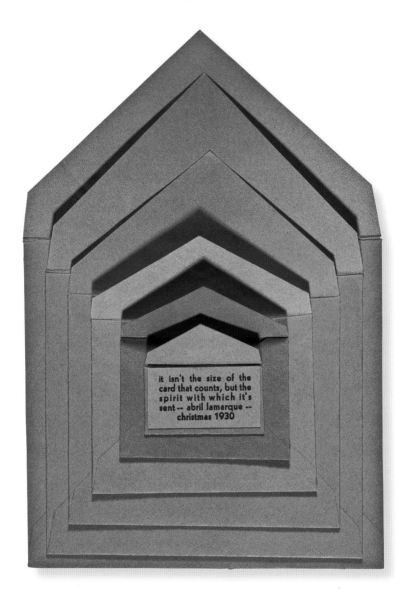

it isn't the size of the
card that counts, but the
spirit with which it's
sent -- abril lamarque --
christmas 1930

Abril Lamarque, unsent, 1930
six paper envelopes
13 x 14 cm
Abril Lamarque papers, 1883–2001

As an amateur magician, Abril Lamarque (1904–1999) often had a few tricks up his sleeve. The Cuban American cartoonist, designer, and art director frequently performed magic shows at Christmas parties for the Society of Illustrators. Lamarque continued to amuse his friends with his holiday greeting of 1930. What appears from the outside to be an average card actually contains five progressively smaller envelopes. The final message, printed on a tiny piece of paper, is a reminder to value sentiment over materialism: "It isn't the size of the card that counts, but the spirit with which it's sent."

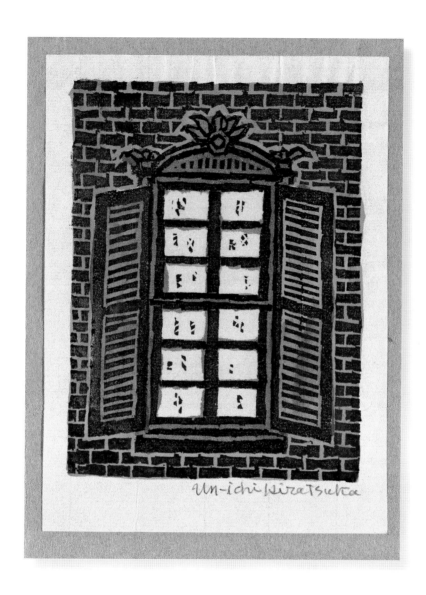

Unichi Hiratsuka to Prentiss Taylor, ca. 1970
relief print
16 x 12 cm
Prentiss Taylor papers, 1885–1991

Unichi Hiratsuka (1895–1997) began his prolific art career in his native Japan, where he learned the *sōsaku hanga* printing method, a modern approach to woodblock printing that emphasizes individualism over team production. In traditional Japanese printing, many people worked to make a single print. *Sōsaku hanga*, developed in the early twentieth century, involved just one artist, from the creative conception of a subject to the print's completion. When Hiratsuka later settled in Washington, D.C., he befriended printmaker Prentiss Taylor. In this holiday card the warm glow emanating from the window invites viewers to imagine the cheerful festivities occurring in the old brownstone abode.

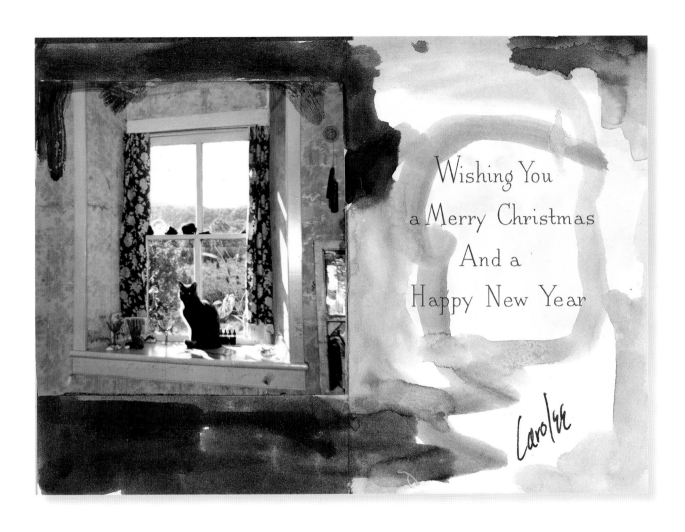

Wishing You
a Merry Christmas
And a
Happy New Year

Carolee

Carolee Schneemann to Joseph Cornell,
ca. 1965
glitter, watercolor, and a photograph
on a commercial card
11.5 x 8 cm
Joseph Cornell papers, 1804–1986

Carolee Schneemann (b. 1939) uses her body to practice art. Since the 1960s her performance-based works have raised critical questions about sexuality, feminism, and society. Her cat, Kitch, however, is the main performer in one of Schneemann's holiday cards to assemblage artist Joseph Cornell. In addition to smears of glitter and swabs of watercolor on an otherwise ordinary commercial card, Schneemann pasted a photo of Kitch—who lived to the ripe old age of twenty—enjoying the view from Schneemann's home studio in Pennsylvania. Schneemann and Cornell corresponded with each other for more than a decade.

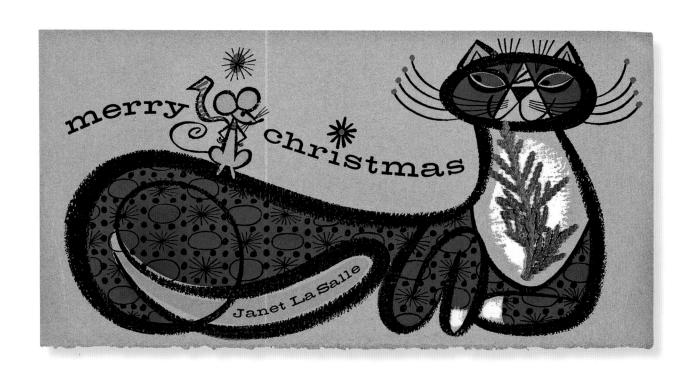

Janet LaSalle to Kathleen Blackshear
and Ethel Spears, ca. 1950
evergreen sprig and gouache on a print
10 x 20 cm
Kathleen Blackshear and
Ethel Spears papers, 1920–1990

Janet LaSalle (1922–1995) honed her midcentury modern vibe as an illustrator of children's books. In a holiday card made around 1950, LaSalle depicted the wary relationship between a sassy little mouse and his smirking feline foe. More than thirty years later, in 1984, the artist and a few friends started a small greeting-card company with a special line devoted to cat themes. LaSalle named the line Porcha, after a cat she found living under her front porch.

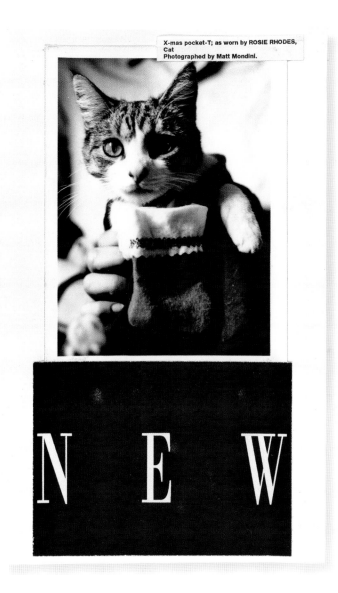

X-mas pocket-T; as worn by ROSIE RHODES, Cat
Photographed by Matt Mondini.

NEW

Susan and Buddy Rhodes to David Ireland,
ca. 1990
collage with a photograph by Matt Mondini
22 x 14 cm
David Ireland papers, 1936–2009

A GAP advertising campaign initiated in 1988, "Individuals of Style," featured black-and-white photographs of celebrities posing in plain T-shirts, with the large GAP logo below each photo. With their cat, Rosie, as the model, Susan (b. 1948) and Buddy (b. 1950) Rhodes styled their New Year's card after the GAP ads. On the receiving end was installation artist David Ireland who, like the Rhodeses, lived in San Francisco, home of GAP headquarters.

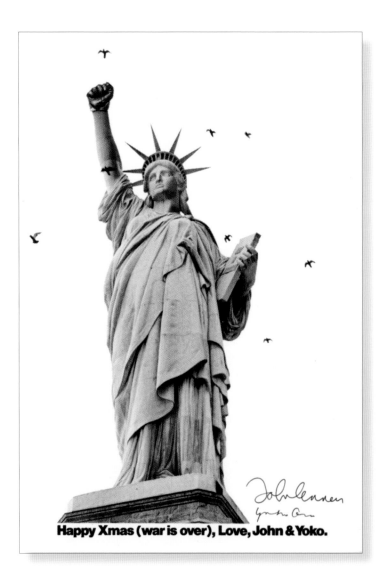

Happy Xmas (war is over), Love, John & Yoko.

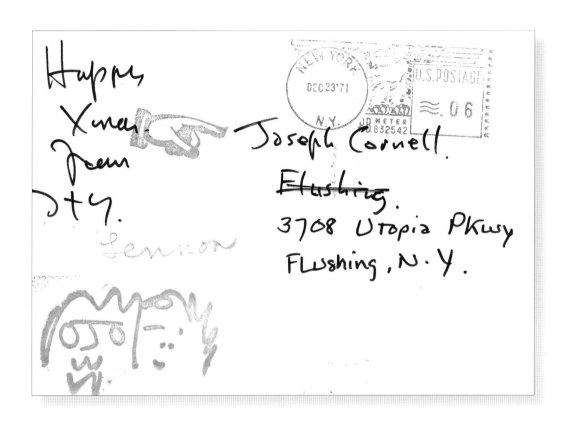

John Lennon (1940–1980) and Yoko Ono (b. 1933) released the song "Happy Xmas (War Is Over)" in 1971 as a musical protest against American combat in Vietnam. Since then, the piece has become a holiday mainstay interpreted by countless artists. In accordance with the lyrics, the couple sent this postcard as a Christmas greeting to artist Joseph Cornell.

4633-2

Peter Bardazzi to Dorothy Miller, 1976
hand-colored photograph
adhered to paper
15 x 11 cm
Dorothy C. Miller papers,
ca. 1912–1992

In the 1970s, Peter Bardazzi (b. 1943) made futuristic collages in reaction to current events in Italy. While visiting Rome, Bardazzi was appalled by the prevalence of neofascism. In response, he collaged art nouveau photographs of Italian women and maps, which together recalled the dark era of fascism in Italy from the 1920s through World War II. Dorothy Miller, curator at New York City's Museum of Modern Art helped Bardazzi sell his *Fascist Dancing Girls Map II* of 1975 to an art collector. As a holiday thank-you card to Miller, Bardazzi sent her a photograph of a dancing girl that he had used in the collage.

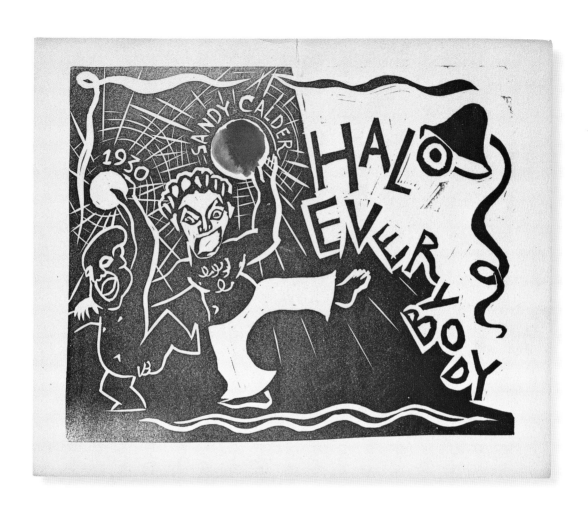

Alexander Calder, unsent, 1929
relief print
23 x 28 cm
Alexander Calder papers, 1926–1967

Influential sculptor and kinetic artist Alexander "Sandy" Calder (1898–1976) chimed in the New Year of 1930 by sending a cheerful linocut of himself in which he is shown jigging arm in arm with Baby New Year. The card hints at the lively character of the work he was making while living in Paris from 1926 to 1933. Calder received critical acclaim for his milestone performance piece, *Cirque Calder*, 1926–31 (Whitney Museum of American Art, New York), a working model circus constructed primarily of wood and wire. The most avant-garde artists in Paris were enamored with Calder's theatrical handling of the kinetic acrobats and animals.

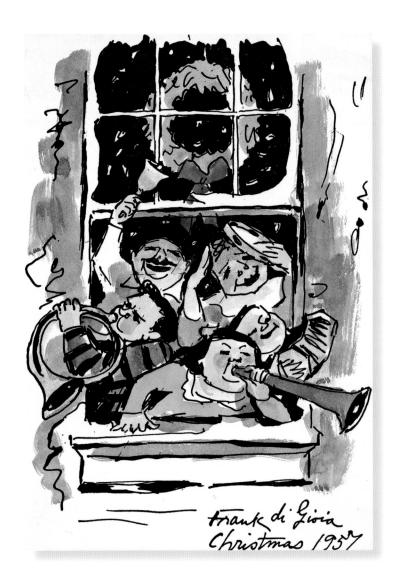

Frank di Gioia
Christmas 1957

Frank Di Gioia to Milch Gallery, 1957
hand-colored print
16 x 11 cm
Milch Gallery records, 1911–1980

Frank Di Gioia (1900–?) frequently exhibited vignettes of life in New York City's Little Italy, from its ebullient festivals to the ubiquitous hot-dog carts. His holiday card of 1957 to his New York dealer, the Milch Gallery, is a delightful glimpse into one Italian family's rowdy celebration.

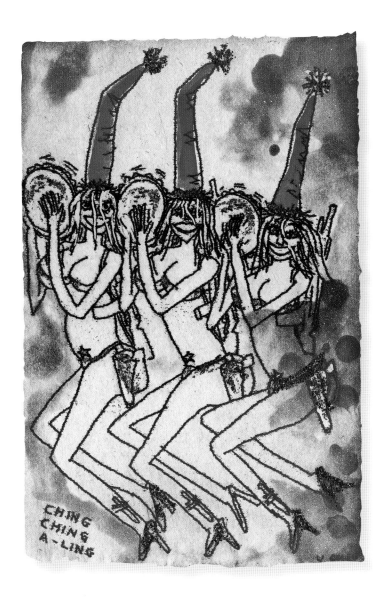

Warrington Colescott and Frances Myers
to Raymond Gloeckler, 2003
intaglio print
22 x 14.5 cm
Raymond Gloeckler papers, 1952–2008

Wisconsin master printmaker Warrington Colescott (b. 1921) draws inspiration from his memory. As a teenager in New Orleans, he was particularly fascinated with the alluring worlds of cabaret and vaudeville. Colescott and his wife, printmaker Frances Myers (b. 1938), imbued their card for 2003 with the glitz, glam, and sex appeal of the dancing women of burlesque. Recipient of the card was printmaker Raymond Gloeckler, the couple's longtime colleague at the University of Wisconsin.

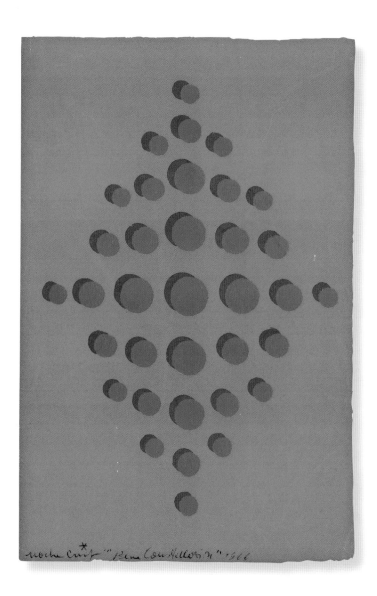

Noche Crist to Leo Castelli, 1966
screen print
21.5 x 14.5 cm
Leo Castelli Gallery records,
ca. 1880–2000

Romanian-born Noche Crist (1919–2004) paid close attention to the inner workings of her mind. As a result, her eclectic artworks cover a range of styles and subjects, from fluorescent abstractions to sensual boudoir scenes. At the time she sent this card to New York art dealer Leo Castelli, Crist's work had taken on a psychedelic edge expressed in neon colors and mind-bending patterns.

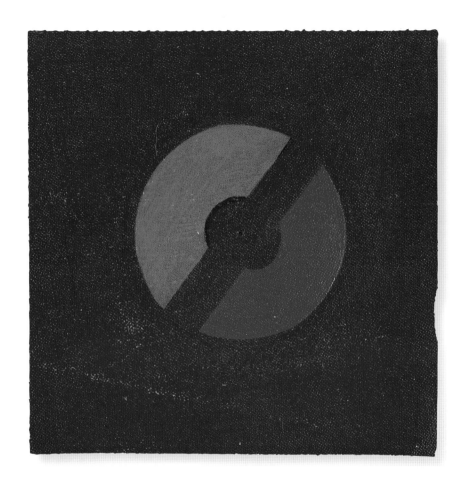

Peter Hutchinson to Robert Smithson,
ca. 1965
acrylic on canvas
18.5 x 18.5 cm
Robert Smithson and
Nancy Holt papers, 1905–1987

In the 1960s, Peter Hutchinson (b. 1930) participated in the burgeoning Land Art movement. Artists like Hutchinson and Land Art pioneer Robert Smithson took art out of museum settings and into nature, often in remote locations. Before working on his large-scale projects, Hutchinson experimented with a series of paintings of geometric forms he called "shape anagrams." For his holiday gift to Smithson, he cut out a detail of a shape-anagram from a larger canvas.

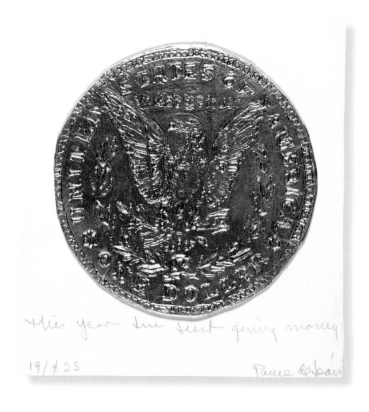

this year I'm just giving money

19/$25

Ponce de Leon

Michael Ponce de Leon to Jacob Kainen, 1965
intaglio print and silver foil
13 x 13 cm
Jacob Kainen papers, 1905–2003

Printmaker Michael Ponce de Leon (b. 1922) broke out of the confines of two-dimensional art for this shiny holiday card. To longtime friend and fellow artist Jacob Kainen, he quipped, "This year I'm just giving money." Ponce de Leon was no stranger to experimenting with unusual printing techniques. His metal printing plates often reached two inches in thickness and comprised wires, washers, chains, and even crushed tin cans.

Boris Artzybasheff to W. Langdon Kihn,
1951
photomechanical reproduction
28 x 20 cm
W. Langdon Kihn papers, 1904–1990

Thinking he was leaving his native Kharkov, Ukraine, to fight in the Russian Revolution of 1917, Boris Artzybasheff (1899–1965) boarded a ship that instead sailed for New York City. Choosing to settle in the United States, Artzybasheff refocused his political passions on his work as a graphic illustrator. Many of his cartoons were biting satires of war and industrialization. He befriended painter Langdon Kihn when their two families retired to Lyme, Connecticut. Although this holiday card is politically neutral, it reveals the illustrator's gutsy sense of humor.

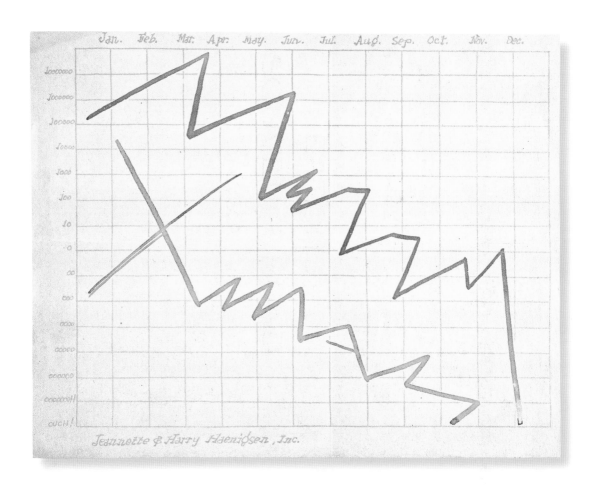

Harry Haenigsen to Alfred Frueh,
ca. 1929
photomechanical reproduction
22 x 28 cm
Alfred J. Frueh papers, 1904–1993

A founding member of the National Cartoonists Society, Harry Haenigsen (1900–1990) made his first comic strip for the *New York World* in 1922. In his Depression-era holiday greeting, Haenigsen used the striking visuals of the stock market crash to wish his fellow illustrator Alfred Frueh a Merry Christmas. He worked steadily as a cartoonist for decades, reaching the height of popularity in the 1940s with his strip, *Penny*. The clever graphics and wholesome anecdotes in *Penny* and his other strips endeared Haenigsen to his readers.

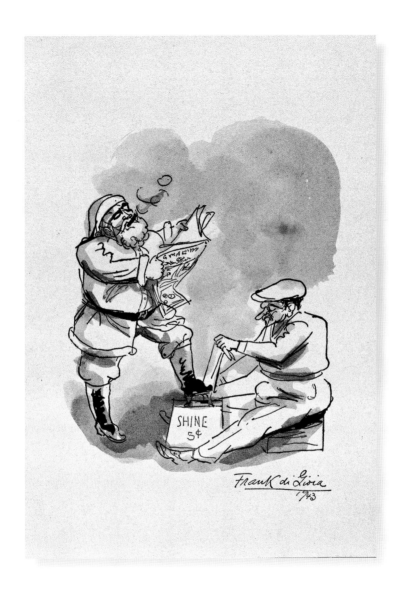

Frank Di Gioia to Dorothy Miller, 1943
ink and watercolor on paper
16 x 11 cm
Dorothy C. Miller papers, ca. 1912–1992

A keen observer of the hustle and bustle of New York City, illustrator Frank Di Gioia (1900–?) captured an off-duty Santa Claus enjoying a break from the hordes of enthusiastic children. Di Gioia was best known for his affectionate satires of life in New York City's Little Italy.

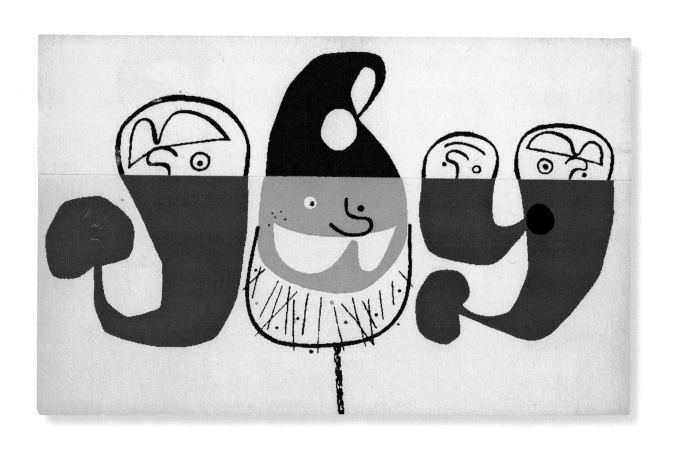

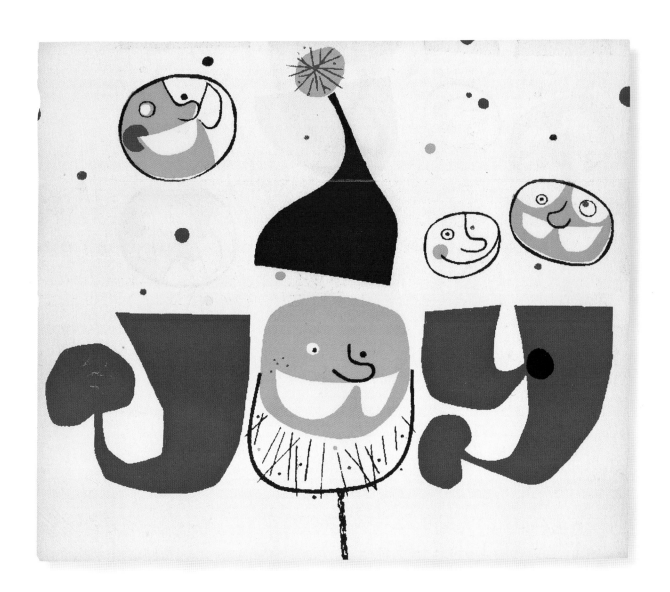

Frederick Hammersley, ca. 1950
screen print
10 x 17 cm
Frederick Hammersley papers, 1897–2008

When opened, this holiday card designed by Frederick Hammersley (1919–2009) shows Santa and his elves losing their hats in the seasonal cheer. The artist's screen print is more lyrical than his abstract paintings of planar shapes. Hammersley and his fellow Los Angeles artists working in a similar style in the 1950s were dubbed the "Abstract Classicists" because their hard-edged geometric subjects were a marked contrast with those of the Abstract Expressionists in New York City.

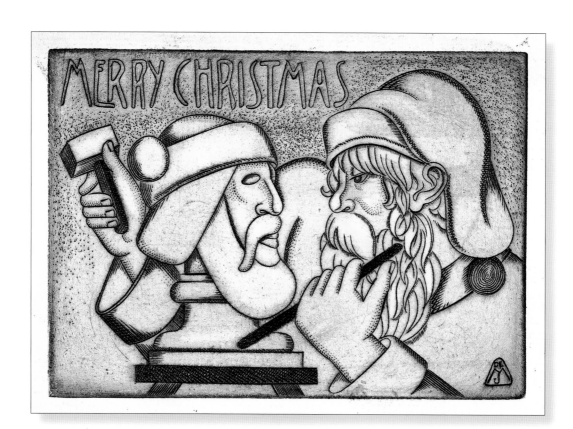

Jean De Marco to Ralph Fabri, 1962
intaglio print
14 x 18 cm
Ralph Fabri papers, ca. 1870s–1975

Jean De Marco (1898–1990) suggests in this etching that not just elves merrily toil away at the North Pole, but rather, Santa himself has a knack for creativity. De Marco and his wife, Clara Fasano, were prolific and highly regarded sculptors. Born and educated in France, De Marco fused traditional subjects with the simplicity of modernism. While many of his works were based on religious themes and commissioned by ecclesiastical and government institutions, his holiday card of 1962 is all about his sense of humor.

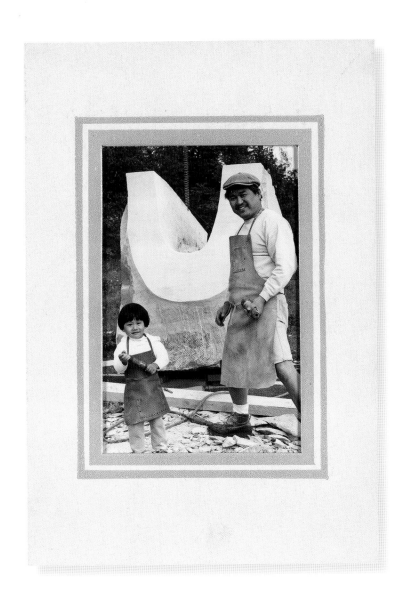

Minoru Niizuma to Dorothy Miller, ca. 1971
photograph adhered to paper
14 x 20 cm
Dorothy C. Miller papers, ca. 1912–1992

A holiday card by Minoru Niizuma (1930–1998) offers a behind-the-scenes glimpse of the sculptor working on one of his massive stone sculptures. Grinning beside Niizuma is a petite studio assistant, his young son. Born in Tokyo, Niizuma moved in 1959 to New York City, where he quickly found admirers of his minimal, organic aesthetic. One of his champions, Museum of Modern Art curator Dorothy Miller, was the recipient of this card.

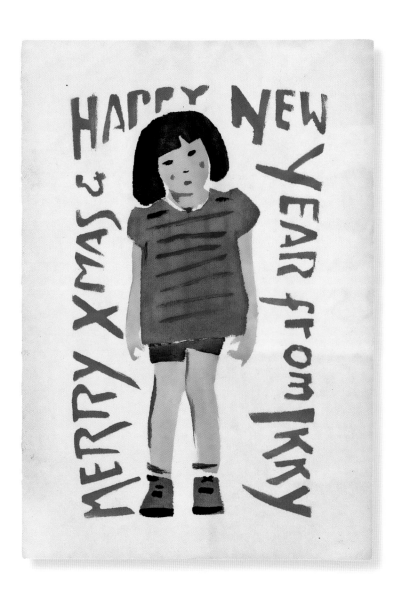

Bunji Tagawa to Fred and Adelaide
Morris Gardner, ca. 1938
watercolor on paper
18 x 12 cm
Fred and Adelaide Morris Gardner
papers, 1916–1978

Tokyo-born Bunji Tagawa (1904–1988) moved to New York City to work as a scientific illustrator. His detailed renderings of mushrooms, molecules, and even the moon were published in numerous books and journals. The focus of his holiday card to Fred and Adelaide Morris Gardner is his inquisitive-looking daughter, Ikuyo "Ikky" Tagawa. Just a young girl in this card, she followed in the creative footsteps of her father and became an architect.

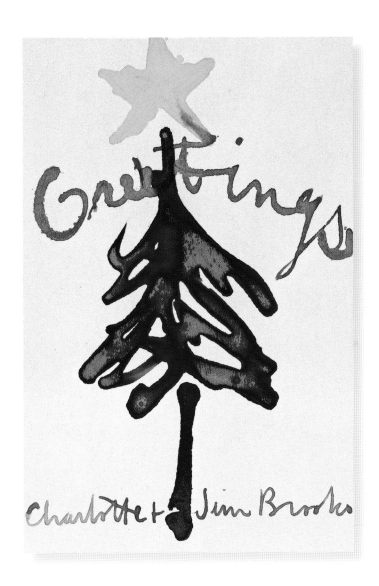

James Brooks to Dorothy Miller, 1969
watercolor on paper
15 x 11 cm
Dorothy C. Miller papers, ca. 1912–1992
© 2012 Estate of James Brooks/
Licensed by VAGA, New York, NY

In 1956, New York City's Museum of Modern Art curator Dorothy Miller organized the watershed exhibition "Twelve Americans" in her efforts to legitimize and lionize Abstract Expressionism. Painter James Brooks (1906–1992) was one of the twelve artists. Born in Missouri, Brooks moved to New York City in 1923. During the Great Depression he made art with social realist themes for the Works Progress Administration. Like many of his contemporaries, Brooks dramatically changed his style after World War II. Influenced by close friend Jackson Pollock, Brooks began experimenting with Abstract Expressionism. In his painting for Miller, loosely applied brushstrokes form an eye-catching Christmas tree.

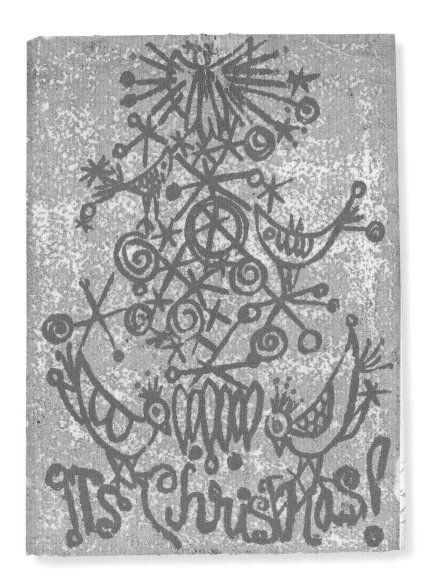

Barbara Aubin to Kathleen Blackshear
and Ethel Spears, ca. 1957
screen print
16 x 12 cm
Kathleen Blackshear and
Ethel Spears papers, 1920–1990

Barbara Aubin (b. 1928), Vera Berdich, Ethel Spears, and Kathleen Blackshear were among a group of influential women artists in Chicago. In her own unique way, each was an incubator of the surrealist and magical realist threads that dominated that city for decades. Aubin's mixed-media collages were often autobiographical in subject, evoking dreams and distant memories. Her silk-screen holiday card is a fantastical, Christmas tree–shaped jumble of stylized birds, ornaments, and an angel.

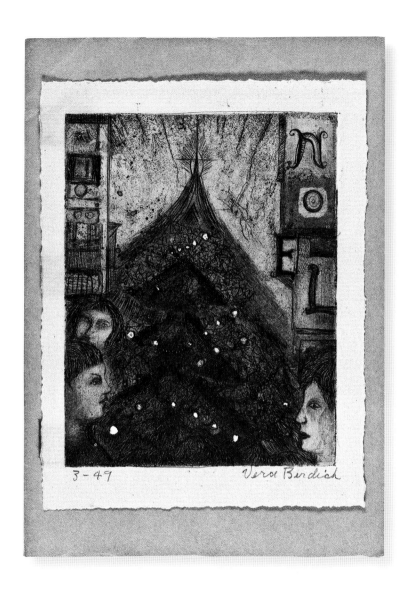

Vera Berdich to Ethel Spears, 1949
intaglio print
19 x 13 cm
Kathleen Blackshear and
Ethel Spears papers, 1920–1990

Vera Berdich (1915–2003) and Barbara Aubin were in the same artistic circle in Chicago, but their printing techniques differed. When Berdich graduated from the School of the Art Institute of Chicago, she found work in the commercial printing business, an experience that would make her one of the first artists to apply photographic techniques to etching. An expert in the medium, she returned to her alma mater to establish the etching department. Her prints often featured surreal portrayals of phantoms, spirits, and other imaginative subjects; even her Christmas card from 1949, of children gathered around a Christmas tree, has an eerie quality to it.

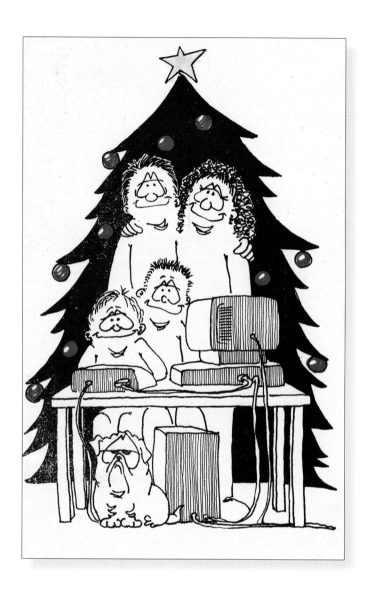

Jill Sheedy to James Mullen, 2000
felt-tip pen on paper
22 x 14 cm
James Mullen Christmas card
collection, ca. 1955–2003

In techspeak, the year 2000 is best remembered as Y2K, when the world watched with bated breath to see if computers could handle the switch from 1999 to 2000. In her clever holiday card, Jill Sheedy illustrated that her family and computers were happily humming along. Sheedy studied with art instructor James Mullen at the State University of New York at Oneonta. Inside the card she reminisces about taking a printmaking course with Mullen in 1975 during her senior year and thanks him for keeping her family on his holiday-card list.

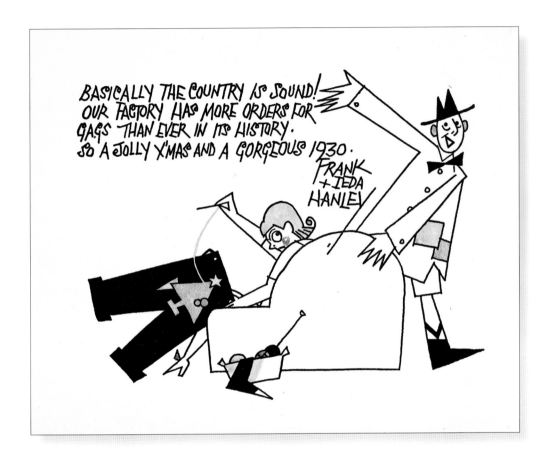

Frank and Ieda Hanley to Louis Lozowick,
1929
hand-colored print
13 x 16 cm
Louis Lozowick papers, 1898–1974

Just months after the crash of the stock market, the American economy was grim. Frank (1894–1986) and Ieda (1894–1994) Hanley printed a satirical holiday card in hopes that 1930 would improve. The couple and the recipient, Louis Lozowick, were politically active artists who supported unions and public aid during the Great Depression.

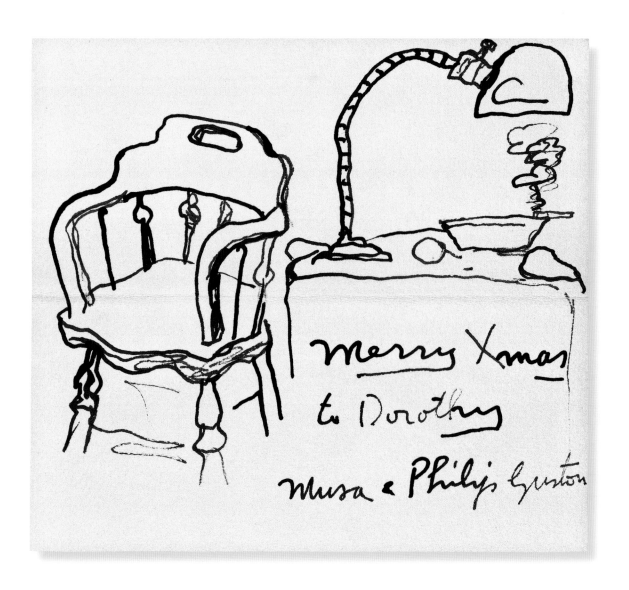

Philip Guston to Dorothy Miller, ca. 1972

watercolor on paper

18 x 20 cm

Dorothy C. Miller papers, ca. 1912–1992

The smoking cigarette resting on an ashtray in this holiday card by Philip Guston (1913–1980) conveys a sense of intimacy, as if Guston had just stood up from the chair and painted a quick sketch of his immediate surroundings. In the early 1970s, around the time he painted the card, Guston was making waves in the art world with his paintings of everyday objects, many found in his studio.

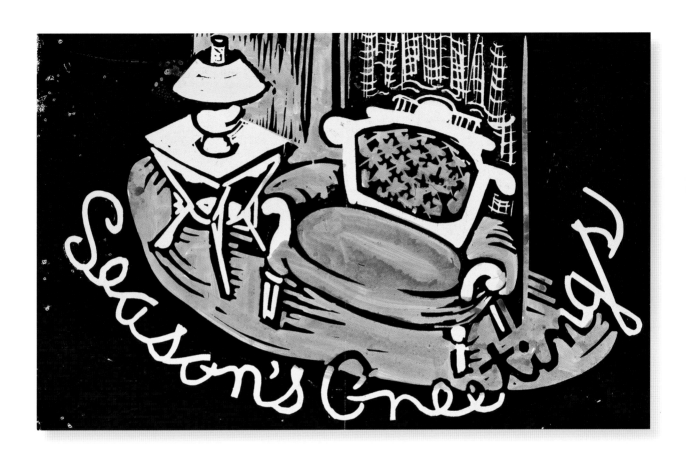

Frances Foote to Prentiss Taylor, undated
hand-colored print
25 x 20 cm
Prentiss Taylor papers, 1885–1991

In the 1940s, Frances Foote met printmaker Prentiss Taylor while she was a young artist in Washington, D.C. When she moved to New York City, she used her holiday card to show off her cozy apartment in Hell's Kitchen, a Manhattan neighborhood.

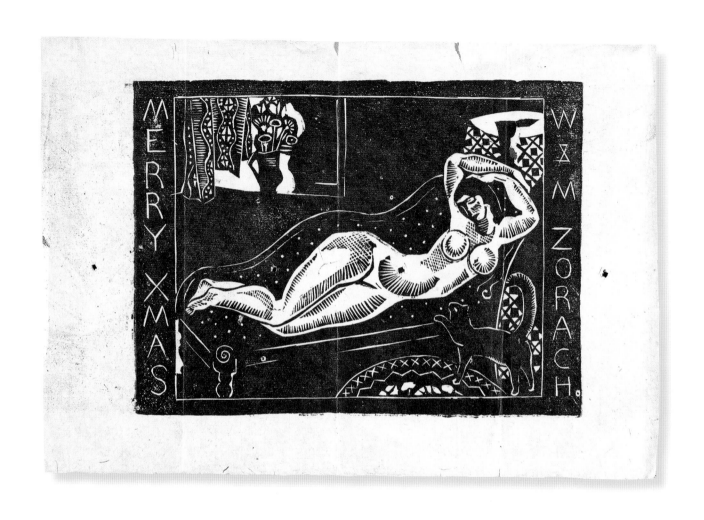

Marguerite and William Zorach
to Antoinette Kraushaar, 1926
relief print
30 x 22 cm
Kraushaar Galleries records, 1901–1968

Artists Marguerite Thompson (1887–1968) and William Zorach (1887–1966) fell in love while studying art in Paris. Greatly influenced by fauvism and cubism during their Parisian foray, the artistic duo returned to New York City, where they married in 1912, to participate in the fledgling American modernist movement. Throughout the 1910s and 1920s, they collaborated on their annual holiday card. Like Marguerite, art dealer Antoinette Kraushaar was one of a few women prominent in the New York art world. She championed the work of the Zorachs as well as that of other American modernists.

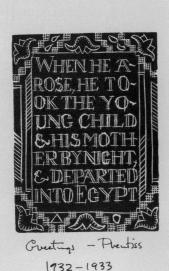

Greetings — Prentiss
1932–1933

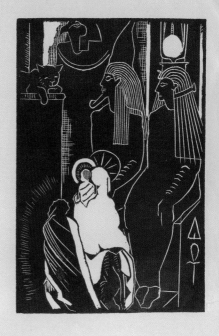

Prentiss Taylor to Robert Franklin Gates,
1932
lithograph
23 x 14 cm
Robert Franklin Gates papers, 1910–1988

When printmaker Prentiss Taylor (1907–1991) moved to New York City in the late 1920s, he befriended photographer Carl Van Vechten and African American poet Langston Hughes. With Van Vechten's encouragement, Taylor and Hughes launched the Golden Stair Press and published a series of books that featured poetry by Hughes and lithographs by Taylor reflecting themes of the Harlem Renaissance. One significant topic was the African American connection to ancient Egypt, evident in Taylor's holiday card of 1932, which illustrates the biblical story of the holy family's flight into Egypt.

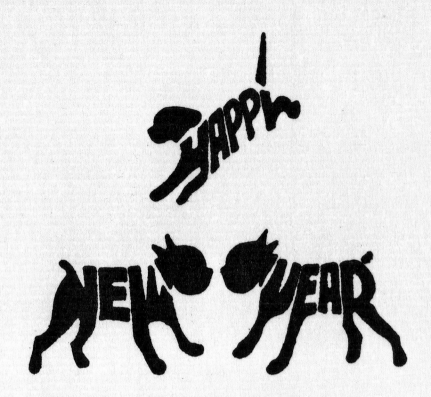

THE JOHN CHARLES CARROLLS

John Charles Carroll to Eleanor Jewett,
undated
block print
10 x 13 cm
Eleanor Jewett papers, 1892–1955

John Charles Carroll (ca. 1886–1939) and Eleanor Jewett worked for the *Chicago Tribune*. Carroll started at the paper in 1919 and remained there as a reporter and editor until his death in 1939. Jewett was hired in 1917 by her cousin, editor Colonel Robert McCormick; within a year she became art editor, a position she held until her retirement in 1956. Jewett had conservative taste in art and frequently wrote criticisms against avant-garde painters and movements in Chicago.

Kay Sage to Eleanor Howland Bunce,
1958
typescript
7.5 x 8 cm
Eleanor Howland Bunce papers,
1935–1982

Kay Sage (1898–1963) was an artist and poet immersed in the Surrealist movement. While living and working in Paris, she fell in love with Surrealist painter Yves Tanguy. With the onset of World War II, the couple fled to New York City. They eventually married and moved to Connecticut. Each year, they created elaborate holiday cards for close friends, including Eleanor Howland Bunce, arts administrator at the Wadsworth Atheneum in Hartford. Sage's card to Bunce from 1958, made with the aid of a typewriter, wished her longtime friend a "Merry Xmas" and "Happy 1959."

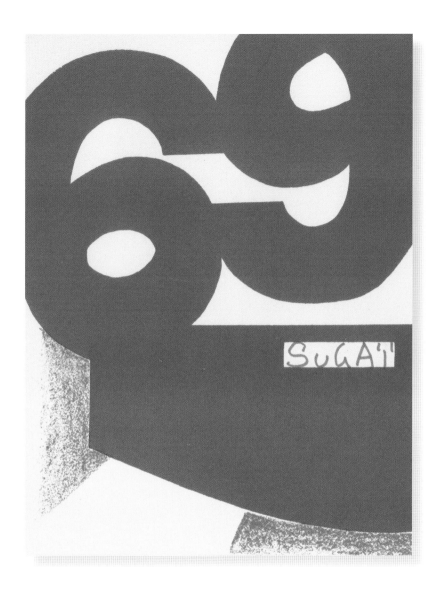

Kumi Sugai to Dorothy Miller, 1968
lithograph
16 x 13 cm
Dorothy C. Miller papers, ca. 1912–1992

When Kumi Sugai (1919–1996) was a student at the Osaka School of Fine Arts in Japan, he was drawn to both traditional calligraphy and modern typography. His general interest in art waned, however, and he dropped out of school to work as a commercial designer for the Hankyu Railway Company. In 1952 he moved to Paris, where a fecund art environment reinvigorated his pursuit of fine art. In the 1960s, when he created this card, he was working with a circle of printmakers experimenting with vernacular signs and symbols. Sugai began incorporating large numbers and capital letters into his art, with each work playing with different colors and typographies.

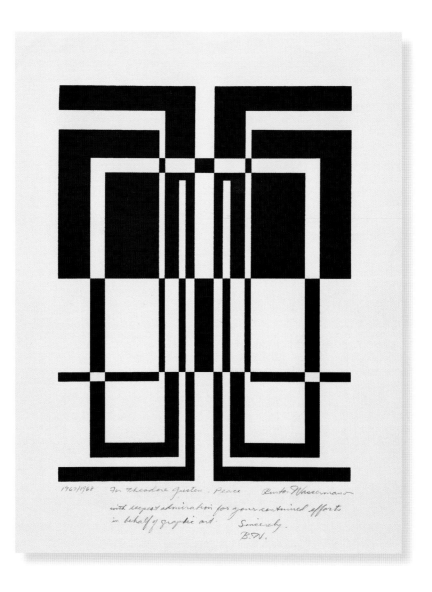

Burton Wasserman to the
Print Council of America, 1967
screen print
28 x 22 cm
Print Council of America records,
1956–2005

In the 1960s the perpetual goal of painter and printmaker Burton Wasserman (b. 1929) was to reduce his forms. Influenced by De Stijl philosophy and his former art teachers at Brooklyn College, Ad Reinhardt and Burgoyne Diller, Wasserman strove to create purely abstract subjects, often consisting of simple vertical and horizontal shapes in a limited color palette. This holiday card sent to the Print Council of America exemplifies his artistic pursuits. In a short note he compliments the work of the Print Council: "With deepest admiration for your continued efforts on behalf of graphic art."

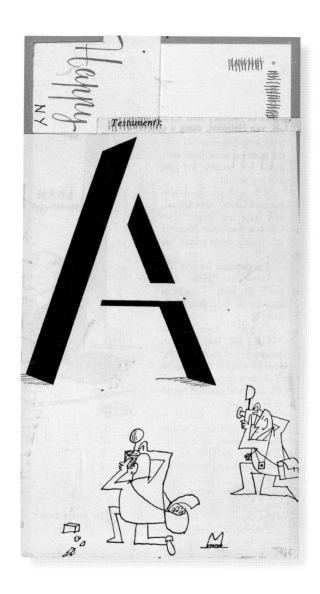

Lenore Tawney to Maryette Charlton, 1965
collage of ink on paper and clippings
9 x 17 cm
Maryette Charlton papers, 1929–1998

Lenore Tawney (1907–2007) reshaped fiber art in the United States when she took her weavings off the loom to freely form large-scale sculptures. Tawney's art became even more multifaceted when filmmaker Maryette Charleton sparked her interest in collage postcards. Tawney sent Charleton numerous postcards, including this holiday collage of clippings and doodles.

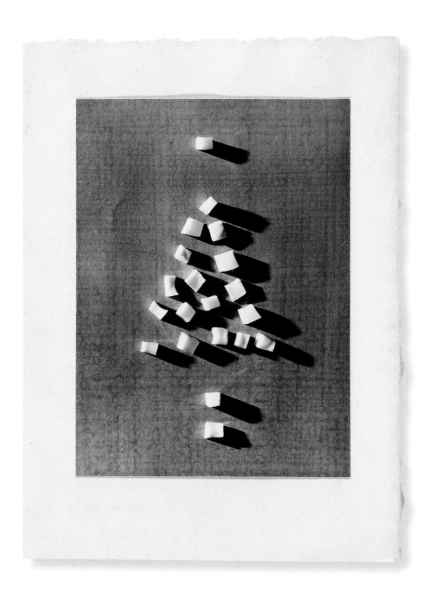

Elsa Schmid to Dorothy Miller, 1959
photograph adhered to paper
20 x 15 cm
Dorothy C. Miller papers, ca. 1912–1992

Elsa Schmid (1897–1970) and her husband, J. B. Neumann, were longtime friends of Dorothy Miller. Schmid was a mosaicist, and Neumann was a founding member of the Museum of Modern Art, New York, where Miller was the museum's first professionally trained curator. In a playful nod to her artistic endeavors, Schmid laid out her mosaic tiles in the shape of a Christmas tree.

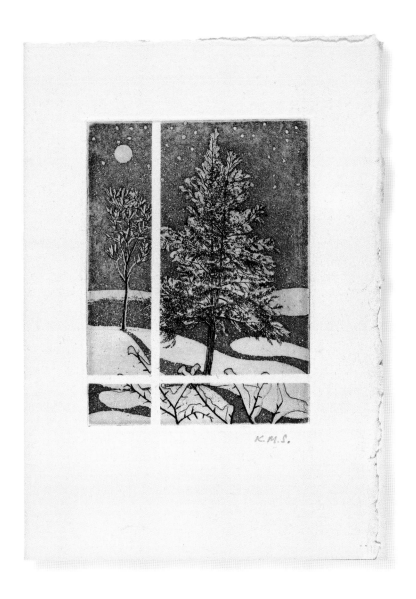

Kathleen Spagnolo to Prentiss Taylor,
ca. 1975
intaglio print
17 x 12 cm
Prentiss Taylor papers, 1885–1991

Kathleen Spagnolo (b. 1919) put into action the saying "No two snowflakes are ever alike." While an art student at American University in Washington, D.C., she learned a multilevel printing technique that ensured each print would be unique. In this holiday card to fellow Washington printmaker Prentiss Taylor, Spagnolo created a moonlit winter evening.

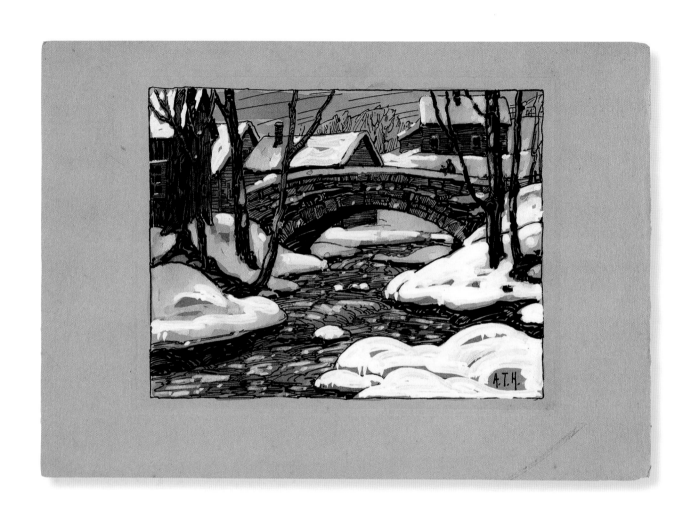

Aldro T. Hibbard to Eric Hudson,
undated
hand-colored print
14 x 20 cm
Eric Hudson and Hudson family papers,
1900–1992

Transporting viewers to a winter wonderland was the specialty of Aldro T. Hibbard (1886–1972). Critics and collectors lauded the painter for his ability to paint snowy landscapes. Hibbard wintered every year in Vermont, where he mastered techniques for translating the picturesque qualities of snow onto canvas. Both Hibbard and the recipient of this holiday card, marine painter Eric Hudson, were "Tarbellites," or students of Edmund C. Tarbell at the School of the Boston Museum of Fine Arts. While Hibbard excelled in painting snow, Hudson was drawn to the equally challenging portrayal of the sea.

Gerry Badger to Samuel Wagstaff, 1980
photograph adhered to paper
13 x 17 cm
Samuel Wagstaff papers, 1932–1985

In 1980 an emerging photographer, Gerry Badger (b. 1948), sent this holiday card to Samuel Wagstaff, an influential curator and private collector of photography. Badger's photograph shows a tangle of dormant trees on the Braan River in Perthshire, Scotland, on Christmas Day 1979. Badger, a native of Northampton, England, has since become a recognized photographer, critic, and curator.

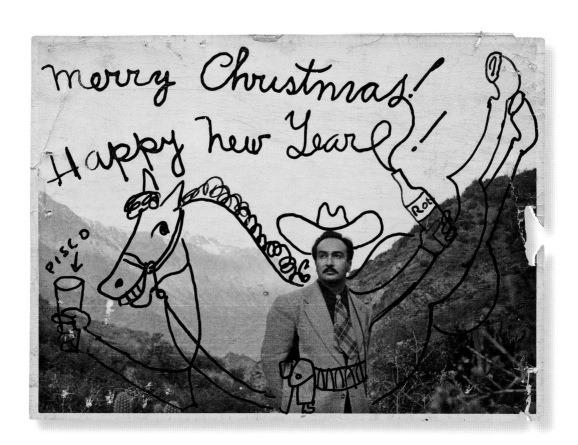

Mario Carreño to Enrique Riverón,
1930
ink on a photograph
12 x 8 cm
Enrique Riverón papers, 1918–1990s

Mario Carreño (1913–1999) and Enrique Riverón were prominent Cuban modernists and lifelong friends. In 1930, the year Riverón moved to New York City, Carreño sent him this photograph of himself decorated with a goofy doodle. Riverón eventually became an American citizen, while Carreño settled permanently in Chile. Pisco, which Carreño and his horse are shown to enjoy, is a popular grape-based brandy in Chile.

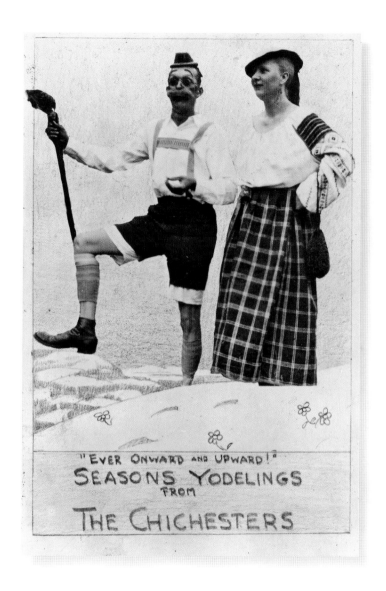

"EVER ONWARD AND UPWARD!"
SEASONS YODELINGS
FROM
THE CHICHESTERS

Cecil Chichester to Konrad and
Florence Ballin Cramer, undated
photomechanical reproduction of a collage
15 x 10 cm
Konrad and Florence Ballin Cramer papers,
1897–1968

Cecil Chichester (1891–1963) credited the utopian spirit of an art colony in Woodstock, New York, as conducive to his picturesque landscape paintings. In 1934, President Franklin D. Roosevelt selected one such work of the Hudson Valley for display at the White House. Chichester's holiday card to fellow Woodstock denizens Konrad and Florence Ballin Cramer reveals his silly side. Chichester wears a traditional Bavarian lederhosen and his wife dons a Scottish skirt and cap as they merrily hike atop a sketch of a snowy mountain.

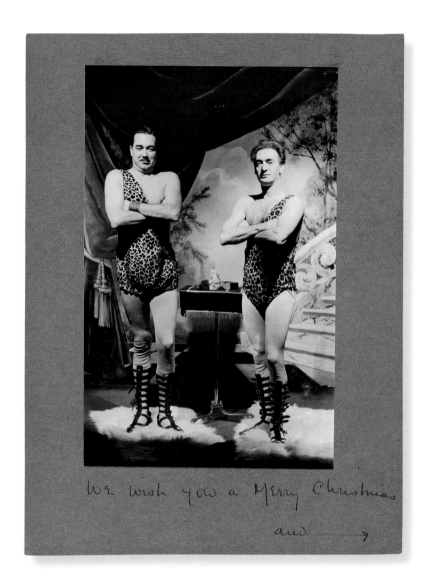

We wish you a Merry Christmas

and ⟶

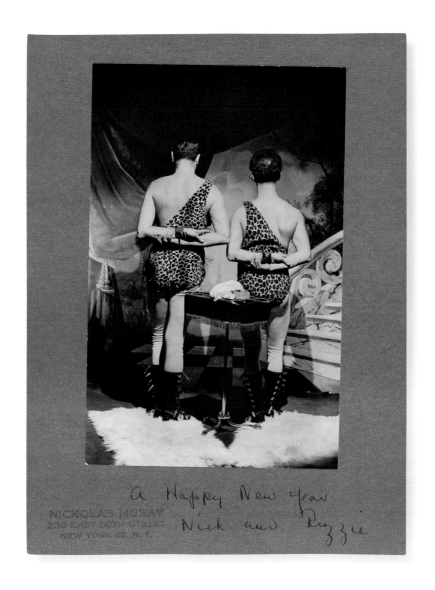

Nickolas Muray, unsent, 1941
photographs adhered to paper
22 x 16 cm
Nickolas Muray papers, 1911–1978
© Nickolas Muray Photo Archives

Nickolas Muray (1892–1965) opened his own photography studio in 1920 and within a year *Harper's Bazaar* hired him to photograph actress Florence Reed. The Hungarian émigré was soon in high demand by popular magazines for his portraits of the rich and famous, including Frida Kahlo, with whom he had a decade-long affair. Like his dazzling subjects, Muray led a fascinating life. In addition to a career as a photographer, he was a member of the U.S. Olympics Fencing Team (1928 and 1932), a pilot during World War II, and an astute collector of Mexican art. In his holiday card of 1941, he took on the persona of a caveman in gladiator boots. He collaborated on his annual holiday card with fellow photographer Ruzzie Green.

Milton Avery to Fred and Adelaide
Morris Gardner, ca. 1939
watercolor on paper
12 x 14.5 cm
Fred and Adelaide Morris Gardner
papers, 1916–1978

As the circus enjoyed mass appeal in the early part of the twentieth century numerous American artists ventured to the Greatest Show on Earth seeking inspiration. Milton Avery (1885–1965) painted dazzling circus performers in his inimitable style that walked its own tightrope between naïveté and modernism. In his holiday card to Fred and Adelaide Morris Gardner around 1939, two trapeze artists swing before a packed crowd. About the same time, Avery made a large-scale painting, *Three Ring Circus* (Wadsworth Atheneum, Hartford, Connecticut), starring acrobats reaching for trapezes, biking on wires, and performing handstands on horses.

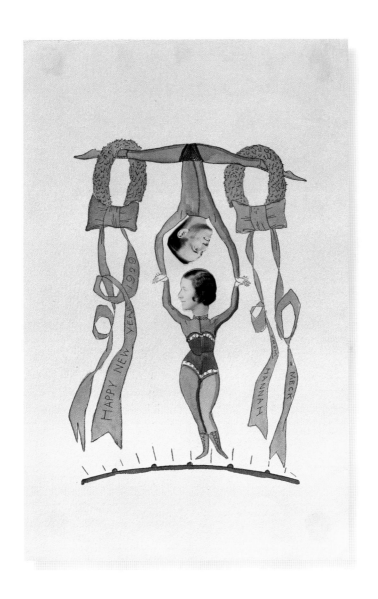

Austin Mecklem and Hannah Small
to Florence Ballin and Konrad Cramer, 1928
collage of watercolor and
a photograph on paper
12 x 13.5 cm
Konrad and Florence Ballin Cramer papers,
1897–1968

Painter Austin Mecklem (1894–1951) and his first wife, sculptor Hannah Small (1903–1992), lived and worked in the free-spirited Maverick Art Colony at Woodstock, New York. The couple showed off their flair for theatrics in their New Year's card for 1929. Recipients Florence Ballin and Konrad Cramer saved the delightful collage in their holiday-card scrapbook. Although the marriage didn't last—in the late 1930s Mecklem married illustrator Marianne Greer Appel and Small married painter Eugene Ludins—they both remained active in the Woodstock art community.

Eugene Bennett to Kathleen
Blackshear and Ethel Spears, undated
screen print
13 x 18 cm
Kathleen Blackshear and
Ethel Spears papers, 1920–1990

Eugene Bennett (1921–2010) once told a friend that he gave up music in favor of art because his art palette was easier to carry than a grand piano. Ever the Renaissance man, Bennett dabbled in a variety of artistic pursuits after he received an art degree on the GI Bill from the School of the Art Institute of Chicago. Projects ranged from preserving historic buildings in his home state of Oregon to fabricating sculptures for the 1962 World's Fair in Seattle. Many of Bennett's oil paintings comprise reverberating orthogonal shapes resembling those in his holiday card.

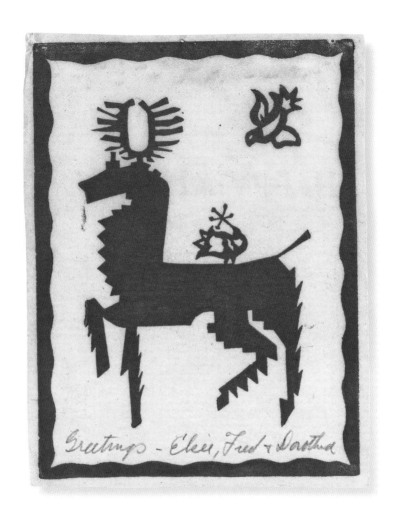

Greetings – Elsie, Fred + Dorothea

Fred Buchholz to Fred and Adelaide Morris
Gardner. ca. 1935
relief print
14 x 11 cm
Fred and Adelaide Morris Gardner papers,
1916–1978

In the 1920s, artist Fred Buchholz (1901–1983) and his wife, Elsie, ran a tea shop in Greenwich Village that was a hot spot for their artist friends. To make ends meet during the Great Depression, Buchholz was forced to drop out of school at the Art Students League and find extra income. He worked first at a printing company and then as a designer for textiles. His simple holiday card packs a punch with its angular shapes and remarkable red.

Xu Bing to Raymond Gloeckler.
ca. 1990
relief print
21 x 28 cm
Raymond Gloeckler papers, 1952–2008

In 1989 students across China demonstrated against the Communist government's martial laws enacted at the expense of human rights. The landmark work *A Book from the Sky*, 1987–91 (Tang Center for East Asian Art, Princeton University, New Jersey), by Xu Bing (b. 1955) was among the cultural objects under scrutiny by the government. The University of Wisconsin offered Xu an honorary fellowship that gave the artist a lifeline out of China. Xu removed a page from *A Book from the Sky* for his holiday card to Wisconsin art professor Raymond Gloeckler. The apparent Chinese characters are not really Chinese at all; rather, they are "characters" that Xu created to challenge conventional structures of language, authenticity, and power.

In the latter half of the 1940s, painter Robert Motherwell (1915–1991) was in an experimental mode, working with calligraphy-influenced line drawings and daubed-on patches of bright color. His holiday card to Joseph Cornell shows the influence of each. The two artists bonded over their shared fascination with the moody, romantic aesthetic of French Symbolism. The deeply philosophical Motherwell steeped himself in French poetry and music, constantly attempting to articulate raw emotion with his abstract paintings.

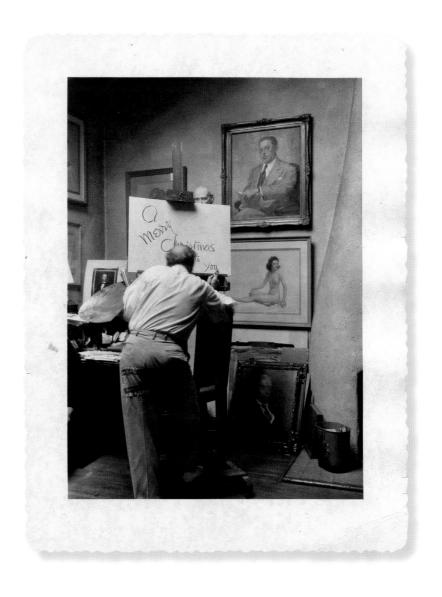

Penrhyn Stanlaws to unidentified
recipient, ca. 1955
photograph
14 x 11 cm
Miscellaneous photographs collection

Painter Penrhyn Stanlaws (1887–1957) often illustrated romantic portraits of rosy-cheeked starlets that graced the covers of the *Saturday Evening Post*. In the 1910s, he signed on to participate in a moving-picture production about his practice as an artist. In an interview with the *New York Times* in 1914, he confessed his stage fright around cameras: "When I was drawing, I had no thought that millions of [people] were looking in at my studio door; otherwise I might have been the victim of some slight embarrassment." By 1955 he had clearly warmed up to a camera presence in his studio.

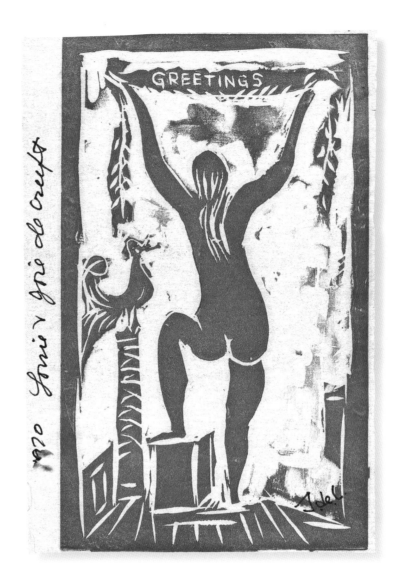

GREETINGS

1970 *Louis y José de Creeft*

José de Creeft to Julian Levi, 1970
relief print
21.5 x 15 cm
Julian E. Levi papers, 1846–1981

In an act of artistic rebellion in 1915, sculptor José de Creeft (1884–1982) broke all his molds in his Paris studio. Although he was still a student, he knew then that his future in sculpture would not follow the traditional academic route. Instead he carved directly into blocks of wood and stone, making decisions spontaneously according to his instinct. The results were modernist, figurative sculptures influenced by Art Deco, Native American, and African aesthetics. His sculptures, however, did not fit easily into envelopes, so for his holiday card to artist and educator Julian Levi, de Creeft created a linocut of a woman decorating her home for the holidays.

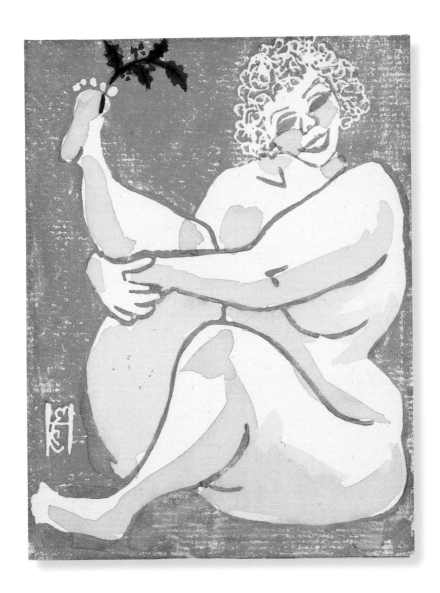

Everett Hart to Eugenie Gershoy,
undated
screen print
14 x 11 cm
Eugenie Gershoy papers, 1914–1983

California artist Everett Hart (1908–1993) adorned the cover of his holiday card to sculptor Eugenie Gershoy with the image of a voluptuous woman wiggling holly between her toes. On the interior he wrote, "Herewith: the irreverent result of taking many life classes!"

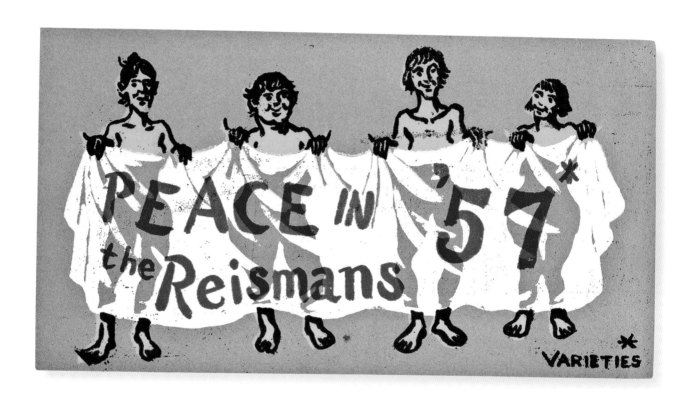

Philip Reisman, unsent, 1956
screen print
15 x 28 cm
Philip Reisman papers, 1904–1994

For decades Philip Reisman (1904–1992) designed and printed his family's annual holiday cards. Born in Poland, Reisman as a young child moved with his family to a tenement in New York City and grew up fascinated by, in the artist's own words, "the poetry in every aspect of life." Reisman, who was Jewish, spent his career documenting social injustices faced by working-class and immigrant communities. His holiday cards—especially one depicting four nudists smirking behind a single sheet of fabric—were generally more playful than his prints or paintings.

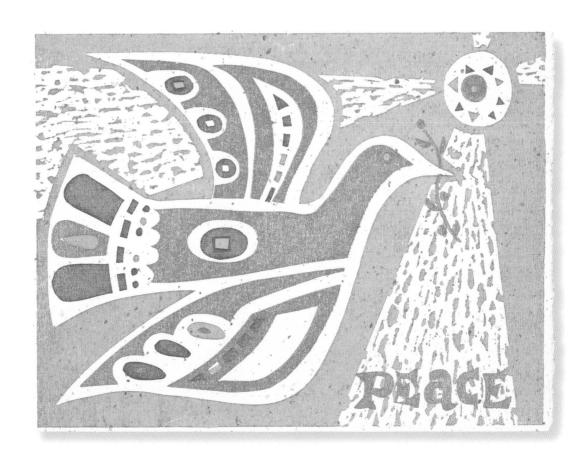

Gordon Kensler to Kathleen Blackshear
and Ethel Spears, ca. 1960
screen print
12 x 16 cm
Kathleen Blackshear and
Ethel Spears papers, 1920–1990

Gordon Kensler (1924–1999) first became involved with silk-screen printing in the late 1940s at the School of the Art Institute of Chicago when he and four other students—Jack Bela, Robert Hiser, Shirley Kifer, and Lynn Lagerstrom—formed the Ghent Guild. The guild designed and printed silk-screen holiday cards and a book, *Fact and Fancy* (1949). Kensler produced cards for his family for many years. Bearing a message of peace, a silver dove glides across Kensler's holiday print to Kathleen Blackshear and Ethel Spears.

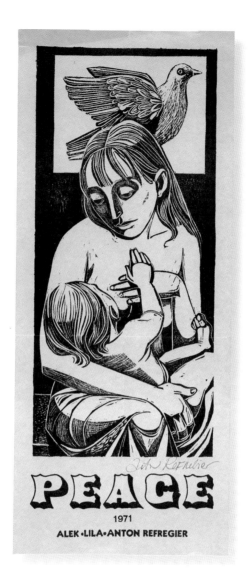

Anton Refregier to Jacob Kainen, 1971
relief print
36 x 15 cm
Jacob Kainen papers, 1905–2003

Anton Refregier (1905–1979) brought art outside museum walls into the public sphere. His murals, many commissioned by New Deal public programs during the Great Depression, focused on humanist themes. Refregier's holiday card of 1971 to printmaker and curator Jacob Kainen features a tender depiction of the Virgin and Child.

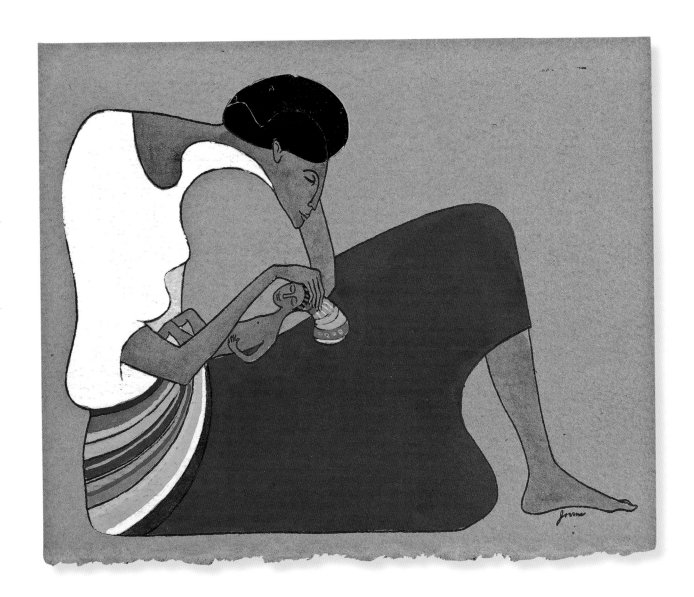

Jean Gerometta to Kathleen Blackshear,
undated
hand-colored print
11 x 13 cm
Kathleen Blackshear and
Ethel Spears papers, 1920–1990

When Jean Gerometta (1928–2006), a native of Gary, Indiana, was young, she attended the University of Chicago and the School of the Art Institute of Chicago, where she pursued her passions in painting, sketching, and poetry. She later became a travel agent and circumnavigated the globe. Her hand-colored print of an African Madonna and Child suggest that her zeal for art and travel merged.

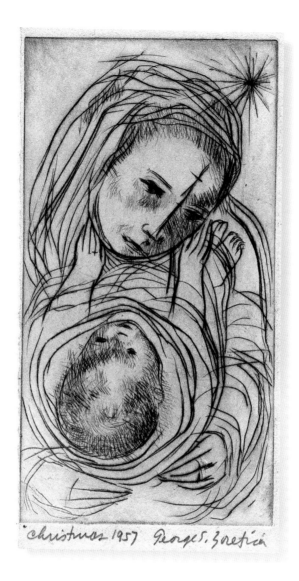

christmas 1957 George S. Zoretich

George Zoretich to James Mullen, 1957
18 x 11 cm
intaglio print
James Mullen Christmas card collection,
ca. 1955–2003

George Zoretich (1918–1995) was one of James Mullen's art professors at Pennsylvania State University, where he developed the department's first courses in printmaking. In Zoretich's efforts to instruct in multiple methods, he created this drypoint print of the Virgin and Child which doubled as his holiday card for 1957. When Mullen became a teacher, he too used this card as an example of the printing technique.

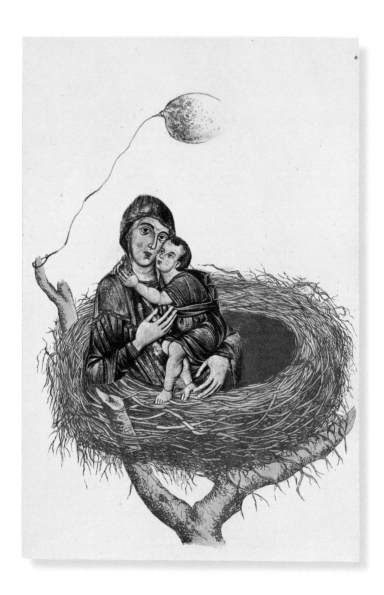

Don Baum to Kathleen Blackshear,
ca. 1965
collage of ink and clippings on paper
19 x 13 cm
Kathleen Blackshear and
Ethel Spears papers, 1920–1990

Don Baum (1922–2008), who helped shape the Imagist movement in Chicago's Hyde Park in the 1960s, was attracted to and intrigued by figurative images around him, especially the ubiquitous icons found in Catholic churches. In his oral history interview with the Archives of American Art, the Presbyterian-raised Baum said about Catholic art: "[It] had a kind of an air of mystery for me, and part of that was because of the image." To enhance the enigmatic qualities of his subjects, Baum manipulated the composition by adding and subtracting details, exemplified in his rendering of a Byzantine-style Virgin and Child settled in a bird's nest.

Richard Tuttle to Samuel Wagstaff, ca. 1970
relief print
11 x 15 cm
Samuel Wagstaff papers, 1932–1985

When Richard Tuttle (b. 1941) was an art student at the Pratt Institute in New York City, he befriended Samuel Wagstaff, then curator at the Wadsworth Atheneum in Hartford. In 1962, Tuttle wrote to Wagstaff that he was wavering in his decision to become an artist, explaining, "As I see it, there are two types of people in the world, those who have to enforce their existence, prove they are a living organism by creating something which is part of them, and those who are dead while living. I cannot decide if I want to live or die." Tuttle chose to live and, as he forecasted, he worked tirelessly to express himself, experimenting with abstract, conceptual, and installation art.

Christmas Greetings

Rowena Fry to Ethel Spears and
Kathleen Blackshear, ca. 1940
screen print
14 x 18 cm
Kathleen Blackshear and
Ethel Spears papers, 1920–1990

Chicago artist Rowena Fry (1892–1990) transformed the hustle and bustle of Chicago into a prosaic neighborhood from another era. Although she studied at the Hubert Ropp School of Art in the 1930s, her flat, decorative style is often described as naïve. Fry made numerous serigraphs of urban winter scenes, many of which she sold at Chicago Art Society holiday fairs and exhibitions, but her close friends and family were lucky enough to receive them in the mail each year.

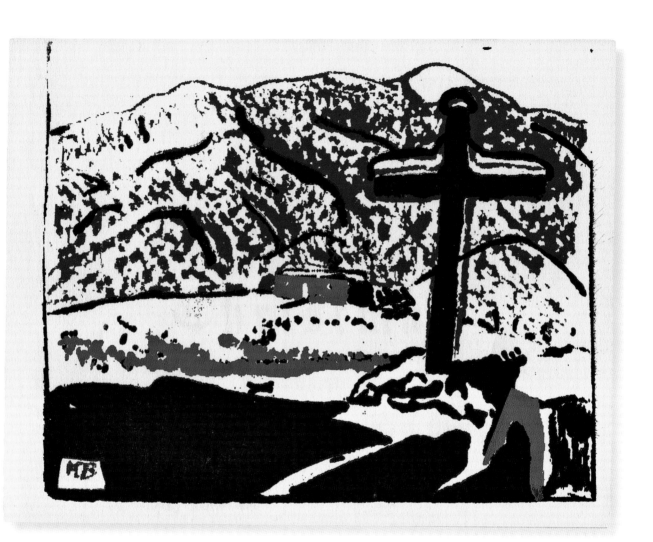

Artist couple Ernest and Mary Blumenschein (1869–1958) could not resist the magnetic energy of Taos, New Mexico. The stunning natural landscape and dynamic local culture—a confluence of Taos Pueblo Indians, the influential Catholic Church, and bohemian artists and writers—provided Mary ample stimulation. In this Christmas card to sculptor Chester Beach, she fused her modernist style with the iconic mountains and a historic site created by the Penitentes, a confraternity of lay Catholics known for their tortuous ascetic practices. The prominent cross, contrasted against the cobalt-blue mountains, is a relic of one of the sect's most grueling observances, in which a member journeyed with a cross on his back, a tradition the Church finally outlawed in 1925.

Denise Browne Hare

Denise Browne Hare to Katharine Kuh, ca. 1980
photograph
13 x 17 cm
Katharine Kuh papers, 1908–1994

Denise Browne Hare (1924–1997) was a photographer of painters and sculptors of the mid-twentieth century, including Joseph Cornell and Philip Guston. Here she sends a reminder to Katharine Kuh, who was a curator at Art Institute of Chicago, to stop and smell the roses.

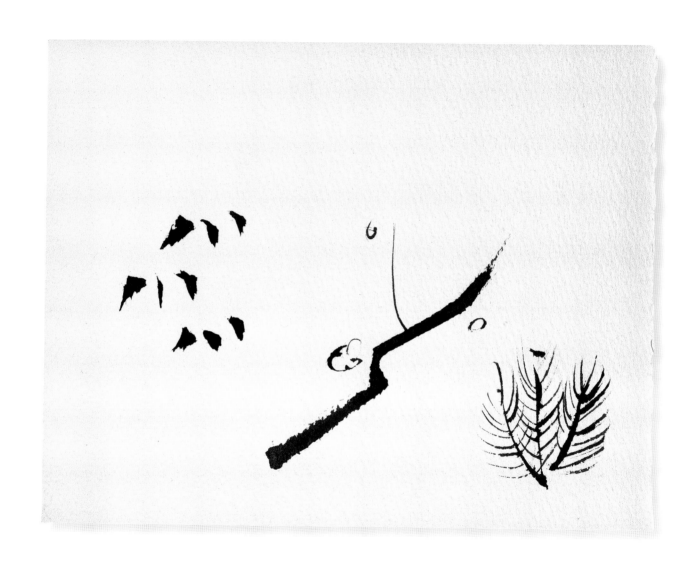

Kenzo Okada to Dorothy Miller, undated
ink on paper
12 x 15 cm
Dorothy C. Miller papers,
ca. 1912—1992

Kenzo Okado (1902–1982) infused his traditional Japanese art education with the zest of Abstract Expressionism. In the 1950s the Tokyo-born painter became active in the New York School, befriending the likes of Clyfford Still and Mark Rothko. Although his New York friends turned inward to find inspiration for their abstract paintings, Okada found some of the best examples of abstraction in nature.

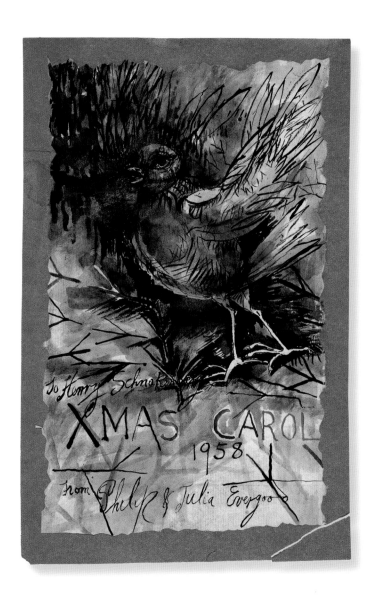

Philip Evergood to H. E. Schnakenberg,
1958
ink on paper
24 x 16 cm
Henry Ernest Schnakenberg papers,
1905–1969

In the midst of the Great Depression, artist Philip Evergood (1901–1973) was on the brink of poverty when art collector Joseph H. Hirshhorn bought several of his works. According to Evergood, that purchase saved his art career. By the late 1950s, Evergood had achieved considerable success. His works had evolved from social realist city scenes of the 1930s to more imaginative, figurative subjects in the 1950s, such as this painterly sketch he and his wife sent to fellow painter H. E. Schnakenberg.

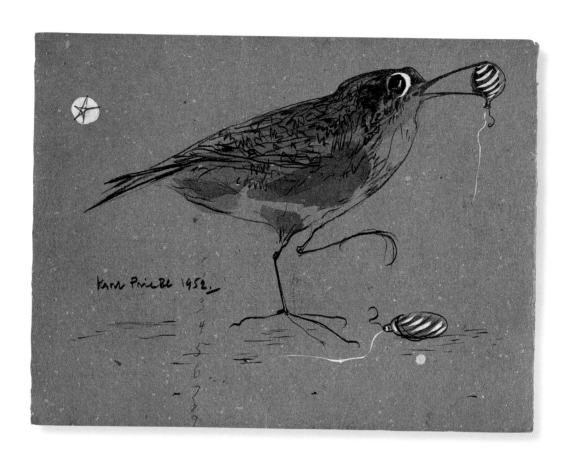

Karl Priebe to Gertrude Abercrombie, 1952
ink and watercolor on paper
12 x 16 cm
Gertrude Abercrombie papers, 1880–1986

While attending art school in Wisconsin, Karl Priebe (1914–1976) frequently visited the Milwaukee County Zoo to observe the birds. His surreal paintings of people and animals—and often hybrids of the two—earned him international awards. Priebe was a longtime friend of fellow Midwestern Surrealist Gertrude Abercrombie, the recipient of his illustration of a wren from 1952. Priebe and Abercrombie palled around together with jazz greats Billie Holiday and Dizzy Gillespie.

A season of Joy

wishing you A season of Joy ~ Mary 12/87

California artist Mary Meyer created a holiday card that, when unfolded, would dramatically reveal a painted collage of handmade pieces of paper. She mailed these nature-inspired compositions to Wisconsin printmaker Raymond Gloeckler.

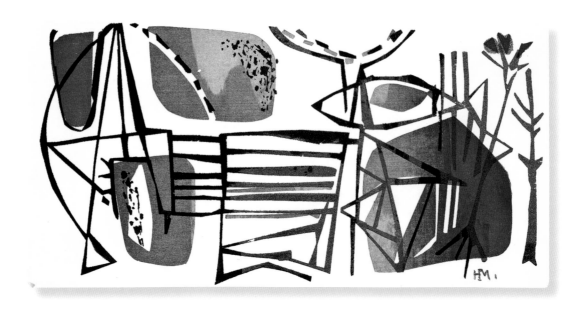

Henriette Mueller
to Kathleen Blackshear and Ethel Spears,
ca. 1955
screen print
11 x 22 cm
Kathleen Blackshear and
Ethel Spears papers, 1920–1990

Henriette Mueller (1915–2009) was decidedly unsympathetic with traditional holiday imagery such as Christmas trees and Santa Claus. But she believed in the spirit of the season, and in her abstract screen print she included the message, "May you see in this Christmas some new wonder and delight...to make it truly a Festival of Light and Peace and Good Will to Men."

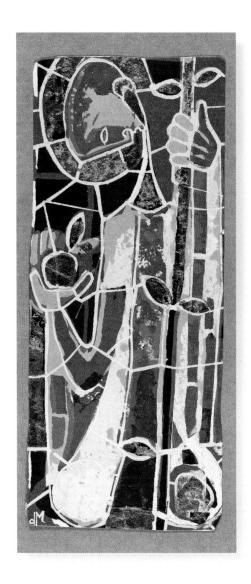

David Manzur to Dorothy Miller, 1958
gold leaf on a screen print
22 x 10 cm
Dorothy C. Miller papers, ca. 1912–1992

The trajectory of David Manzur (b. 1929) as an artist took him down many paths, from abstraction to romanticism. In the 1950s, Manzur moved from his native Colombia to New York City to study at the Art Students League. In New York City he met Museum of Modern Art curator Dorothy Miller. Manzur eventually returned to Colombia, where he found his niche in painting large, moody subjects evocative of the Renaissance period.

Gertrude Lagerstrom
to Kathleen Blackshear, 1955
hand-cut paper
18 x 13 cm
Kathleen Blackshear and
Ethel Spears papers, 1920–1990

Artist and instructor Gertrude Lagerstrom (1913–2003) helped shed light on silhouette art, a practice she traced back to the beginning of paper making in China. With delicate scissors in hand, Lagerstrom fashioned enchanting vignettes out of glossy magazine pages. In a handwritten note inside the card, Lagerstrom urges Blackshear to view the Christmas display in the American Airlines window on Wabash Avenue in Chicago. If Lagerstrom enjoyed creating small-scale displays, she likely couldn't resist the large-scale, opulent winter wonderlands of storefront windows.

CHRISTMAS TIDINGS

(continued on pp. 94–95)

Michiko Sato, purchased card, ca. 1950
12 x 12 cm
relief print
Kathleen Blackshear and
Ethel Spears papers, 1920–1990

German painter Paul Wieghardt (1897–1969) and his wife, Ellie Bar, fled Germany to the United States during World War II because Bar was Jewish. They made their way to Chicago, where Wieghardt worked with Ludwig Mies van der Rohe at the Illinois Institute of Technology. Around 1950 the Wieghardts opted to buy their holiday cards from Michiko Sato (1925–1992). Michiko was among many young artists in Chicago at that time who made holiday cards to sell at local arts and crafts fairs. The folksy style of this nativity scene (continued on pp. 94–95), and other images Sato created, appealed to Kathleen Blackshear and Ethel Spears as well, who also collected a few of Sato's cards.

Michiko Sato, purchased card, ca. 1950
12 x 31 cm
relief print
Kathleen Blackshear and
Ethel Spears papers, 1920–1990

continued from page 93

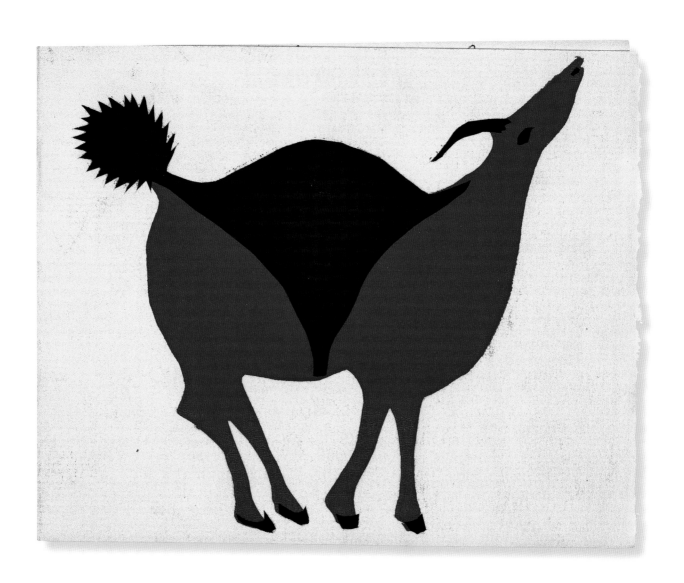

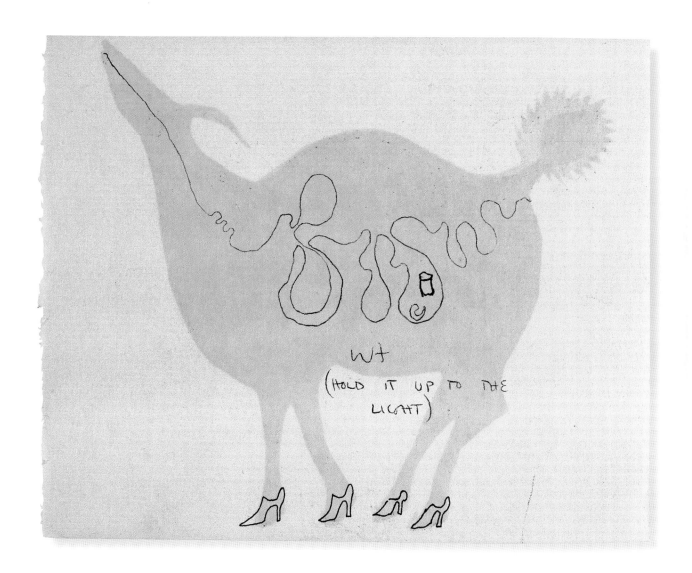

wt

(HOLD IT UP TO THE LIGHT)

Students at School of the Art Institute
of Chicago to Ethel Spears, undated
screen print and ink
11 x 14 cm
Kathleen Blackshear and
Ethel Spears papers, 1920–1990

At the end of every fall semester, students often scramble to get off campus and home for the winter holidays. Although they remain anonymous today, a handful of Ethel Spears's students at the School of the Art Institute of Chicago took the time to create this holiday card for their inspirational art instructor. The screen-printed bushy-tailed antelope on the front is a treat in itself, but the interior holds an amusing surprise: one creative individual doodled—it is hoped not during one of Spears's lectures—the inner workings of the animal, complete with a small can in the antelope's stomach. On the back of the card the students signed their first names, some with a tiny sketch.

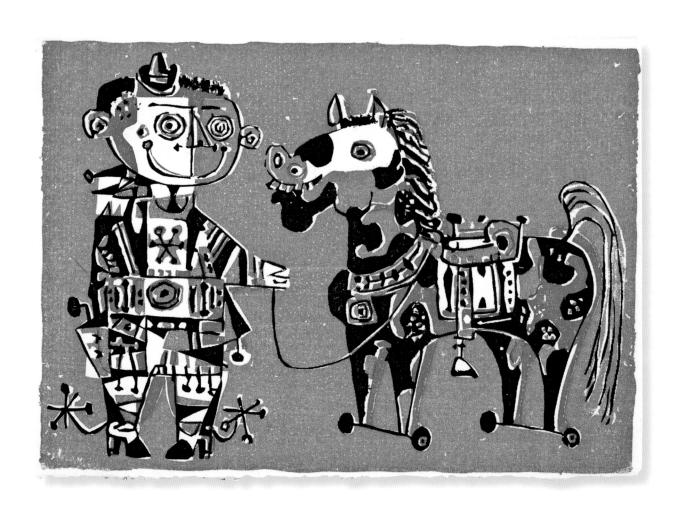

Herman H. Graff
to Kathleen Blackshear, ca. 1955
screen print
13 x 18 cm
Kathleen Blackshear and
Ethel Spears papers, 1920–1990

As a student of Kathleen Blackshear's at the School of the Art Institute of Chicago, Herman H. Graff (1921–2004) made this retro-futuristic screen print of a young cowboy with a pony. After graduating, Graff taught at the California State University of Long Beach from 1964 until his retirement in 1986.

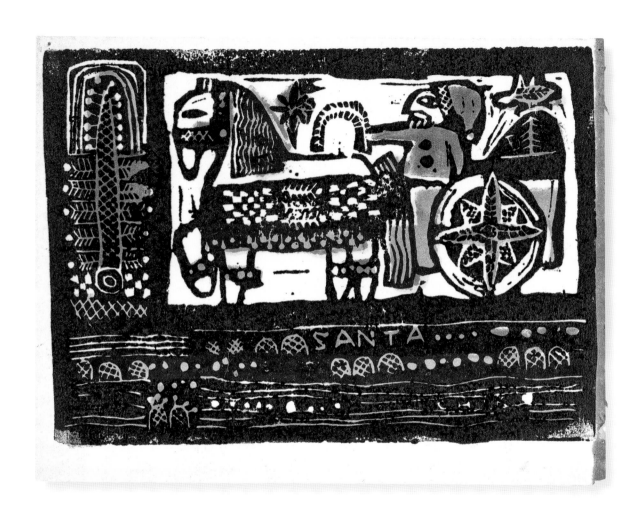

Michiko Sato to Kathleen Blackshear and
Ethel Spears, ca. 1947
relief print
12 x 16 cm
Kathleen Blackshear and
Ethel Spears papers, 1920–1990

Perhaps most well-known as a Chicago textile designer and quilter, Michiko Sato (1925–1992) also earned a cult following for her holiday card designs. Her flattened figures and decorative patterns harked back to a simple— if not imaginary—era when Santa Claus traveled by horse and cart.

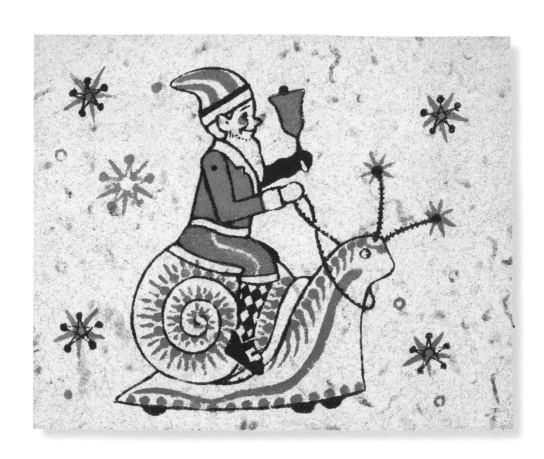

Mildred Waltrip
to Kathleen Blackshear, ca. 1955
screen print
11 x 14 cm
Kathleen Blackshear and
Ethel Spears papers, 1920–1990

A graduate of the School of the Art Institute of Chicago, Mildred Waltrip (1911–2004) worked as a graphic designer for the local Brookfield Zoo and as a children's book illustrator. Her card to Kathleen Blackshear begs its viewers to calculate the logistics of Santa Claus navigating the globe on a snail. Waltrip's kicky sense of whimsy is clear from the subject matter to Santa's argyle socks.

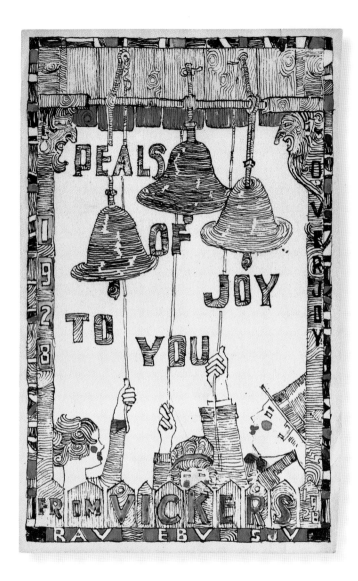

Squire Vickers to Fred and Adelaide Morris
Gardner, 1928
hand-colored print
19 x 12.5 cm
Fred and Adelaide Morris Gardner papers,
1916–1978

Squire Vickers's greatest accomplishments are not found in art museums, but rather, within the depths of the New York City subway. In 1916, Vickers (1872–1947) became the subway's chief architect and worked to overhaul the system's appearance. With a bold sense of color and geometry, he added the now-iconic mosaic signs to the underground railway's walls. Many of his holiday cards echo the aesthetic of his day job, evident in the tessellated patterns and graphic block lettering. One recipient of Vickers's annual holiday card was his colleague and fellow artist Fred Gardner, who worked at the New York City Board of Transportation.

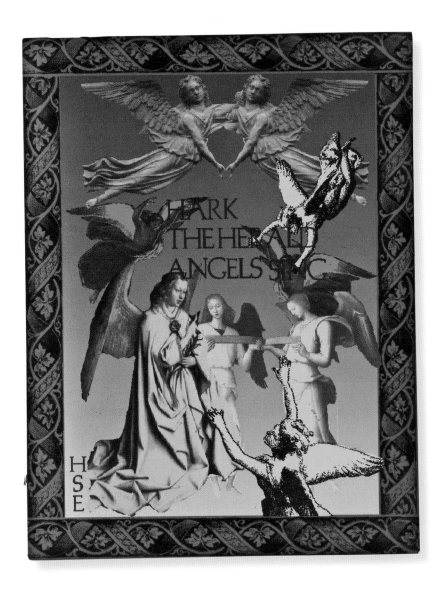

Heidi Everhart to David Ireland, 1993
inkjet print
16 x 20 cm
David Ireland papers, 1936–2009

Heidi Everhart (b. 1966) first met installation artist David Ireland at a holiday party at the Fabric Workshop in Philadelphia. Days later, she created a collage of angels digitally cropped from Renaissance paintings with the computer program U4ia, used for textile design in the fashion industry, and mailed it to Ireland in time for Christmas. In her note on the back, Everhart nicknames Ireland "twinkle toes" for his dashing dance skills and prods him to write back, "My mailbox is waiting for the onslaught of mail from a certain artist in San Francisco." Over the next few years, they exchanged numerous letters and cards.

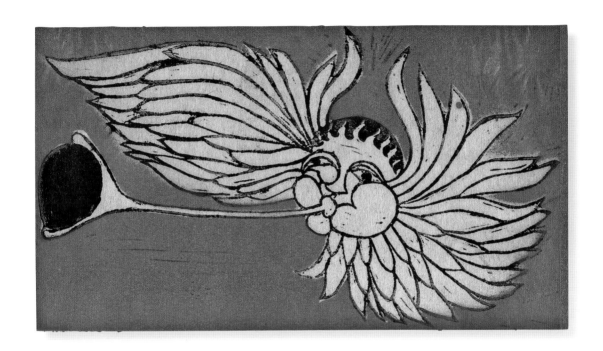

Walter Hahn to Kathleen Blackshear, 1959
relief print
9 x 17 cm
Kathleen Blackshear and
Ethel Spears papers, 1920–1990

Walter Hahn (b. 1927) placed mythological figures against striking, decorative backgrounds. When Hahn made this holiday card for Kathleen Blackshear, he was immersed in a series of works involving the decorative wings of angels. In 1964, frustrated by the dominance of Pop art, Hahn stopped painting. He became an expert on the Japanese tea ceremony and designed bamboo teaspoons used in the ceremonies.

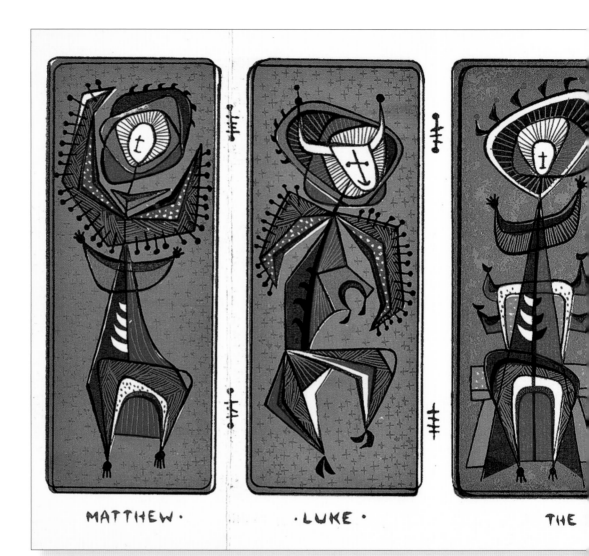

MATTHEW· ·LUKE· THE

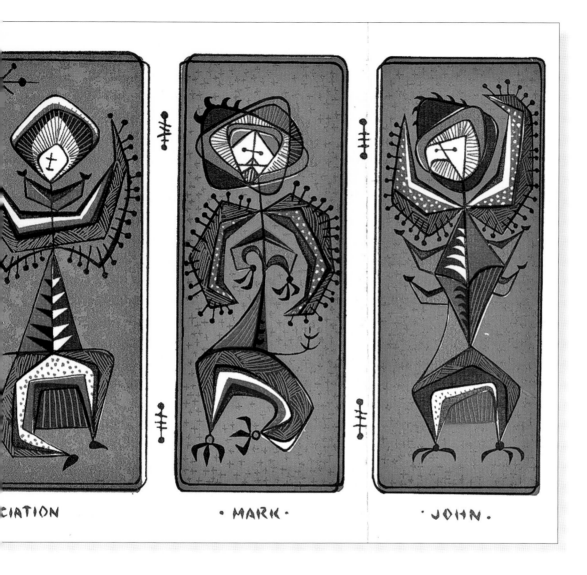

CIATION · MARK · · JOHN ·

Bill Brincka to Ethel Spears and
Kathleen Blackshear, undated
screen print
18 x 40 cm
Kathleen Blackshear and
Ethel Spears papers, 1920–1990

On an aircraft carrier during World War II, Bill Brincka (1927–2001) took the time to build an altar out of found materials in time for a Christmas Mass. After serving in World War II and the Korean War, he finished his master's degree in art and began a thirty-year teaching career at the School of the Art Institute of Chicago. Brincka's penchant for religious symbolism remained evident in his annual screen-printed holiday cards. In the center of the polyptych is a stylized portrayal of the Annunciation. Flanking the Virgin and Angel are the Four Apostles, represented by the attributes ascribed to them in Christian symbolism: Matthew as a man, Luke as a calf, Mark as a lion, and John as an eagle.

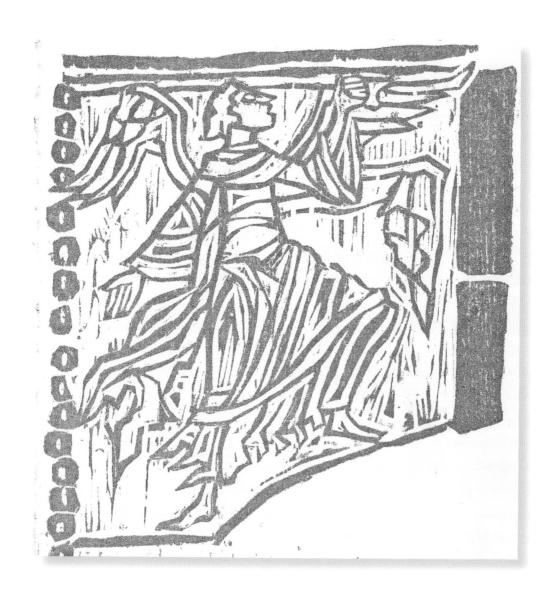

Valerie Thornton to Jacob Kainen, 1983
relief print
17 x 16 cm
Jacob Kainen papers, 1905–2003

London-born Valerie Thornton (1931–1991) derived much of her inspiration from centuries-old churches and historical sites across Europe. She traveled frequently and widely, producing mesmerizing etchings of Romanesque architecture in Spain, Italy, and France. In her 1983 holiday card to Washington, D.C., printmaker and curator Jacob Kainen, Thornton used gray ink to relate her relief print to its weathered stone source.

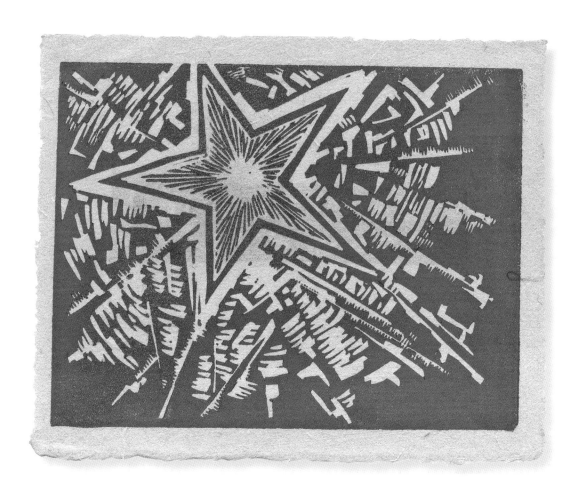

Minnie S. Martin to James Mullen,
ca. 1966
relief print
13 x 17 cm
James Mullen Christmas card collection,
ca. 1955–2003

In 1963, Minnie Martin hired James Mullen to teach at the State University of New York at Oneonta. The colleagues soon became friends. Each year all faculty members of the art department would receive one of her hand-printed holiday cards just before she hosted her annual Christmas dinner at her apartment. For this holiday linocut, Martin used special antique rice paper.

teardrop-eyed little child

an innocent rosy-cheeked face, with realistic eyelashes

Thomas Lanigan-Schmidt
to Arthur Danto, 1992
collage of a photograph, clippings,
and ink on paper
9 x 5 cm
Arthur Coleman Danto papers,
1979–1998

The work of Thomas Lanigan-Schmidt (b. 1948) celebrates kitschy and sometimes downright wacky imagery. The artist mines from a diverse visual vocabulary to mediate his ongoing advocacy for gay rights and his working-class Catholic background. In his holiday card to art critic and writer Arthur Danto, he pasted a photograph of himself over a clipping of a doll. With a gold pen he embellished his "self-portrait" with a rosary, a Bible, and angelic wings.

CHRISTMAS
IS
FOR
CHILDREN

Robert Smithson, unsent, ca. 1964
photomechanical reproduction
21.5 x 18 cm
Robert Smithson and Nancy Holt papers,
1905–1987

Robert Smithson (1938–1973) was a pioneer of the Land Art movement in the mid-1960s, which culminated with his ambitious *Spiral Jetty* of 1970 in Utah's Great Salt Lake. Perhaps less known about the artist was his love for cinematic thrillers, especially *Village of the Damned* (1960) and its sequel, *Children of the Damned* (1964). Onto advertising art from the latter film, Smithson superimposed white lightning bolts to emphasize the children's possessed stares. In 1964, around the time he made this card, Smithson was working on a series of paintings of these stylized lightning bolts. He named one such painting after the crime drama *High Sierra* (1941) starring Humphrey Bogart.

August Arp, unsent, 1922
hand-colored print
17 x 12.5 cm
August Arp papers, 1927–1981

Ringing in the new year of 1923 with a jovial jig, this satyr and his woodland companion illustrate the art nouveau flair that made August Arp (1894–1968) popular among his commercial clients. When he wasn't designing cards, the outdoorsman could be found painting *en plein air* from upstate New York to New Mexico, often alongside his friend, artist John Sloan.

Adelaide Morris Gardner, unsent, ca. 1936
intaglio print
12 x 14.5 cm
Fred and Adelaide Morris Gardner papers,
1916–1978

When Adelaide Morris (1898–1974) fell in love with the man who would become her husband, Fred Gardner (1880–1952), he was her drawing instructor at the Brooklyn Evening Technical and Trade School. Upon her graduation, the two worked together at the New York City Board of Transportation, where they kept their relationship under wraps because it violated the agency's policy. When Adelaide made this engraving around 1936, they had finally married. Influenced by their friend, artist John Sloan, the bohemian couple was active for years in the Society of Independent Artists and relished painting trips throughout North America.

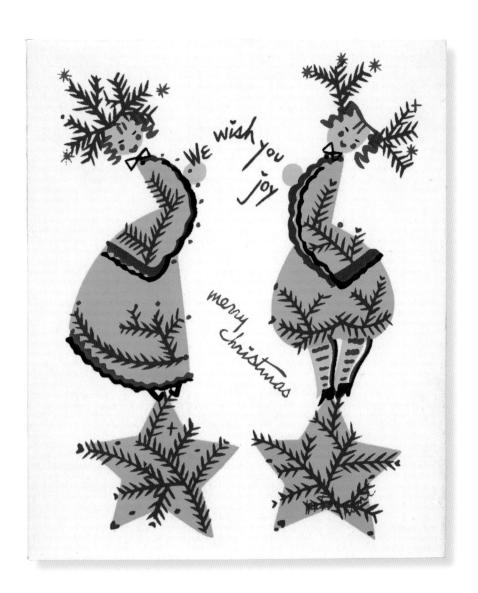

Peter Hunt, unsent, ca. 1940
screen print
12 x 10 cm
Peter Hunt papers, 1788–1968

Provincetown artist Peter Hunt (1896–1967) promoted his folksy style with elaborate stories about his life and travels, most of which were untrue. He designed and produced a small line of screen-printed holiday cards in his signature style. This card from his line depicts rosy-cheeked well-wishers adorned with sprigs of holly.

Henry Pearson to Dorothy Miller, 1968
screen print
18 x 13 cm
Dorothy C. Miller papers, ca. 1912–1992

In 1968, when Henry Pearson sent this card to Museum of Modern Art (MoMA) curator Dorothy Miller, he was closely associated with the Op Art movement. MoMA had recently included Pearson in its watershed exhibition "The Responsive Eye," which featured optical illusions that provoked visitors to reconsider basic concepts of seeing and comprehending art. Pearson's works were indeed eye-catching, but what set them apart were their poetic evocations of rippling water. Although born in North Carolina, Pearson had found his passion for art in Japan, where he worked as a cartographer for the U.S. Army. His prints and paintings echoed the radiating lines of his topographical maps.

Lawrence Kupferman to Dorothy Miller,
ca. 1950
screen print
12 x 27 cm
Dorothy C. Miller papers, ca. 1912–1992

In his oral history interview with the Archives of American Art in 1971, Lawrence Kupferman (1909–1982) described himself as a "Surrealist-Expressionist" because his unconventional works are surreal in their organic forms and expressive in their sensitivity. Raised in Boston by his working-class Jewish parents, Kupferman studied art in the 1940s at the School of the Museum of Fine Arts, Boston and the Massachusetts School of Art. For many summers, he fled Boston for Provincetown, Massachusetts, to meet and mingle with prominent New York Abstract Expressionists, including Hans Hoffmann and Robert Motherwell.

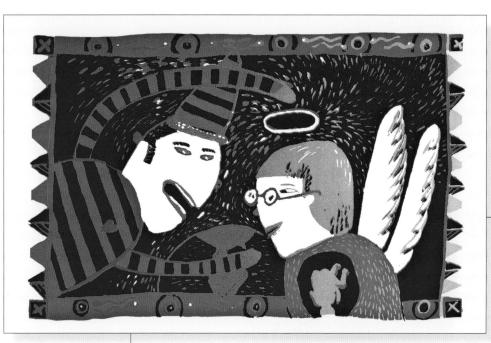

Ed Bisese to Herbert Waide
Hemphill Jr., 1992
screen print
14 x 22 cm
Herbert Waide Hemphill papers,
1776–1998

Ed Bisese (b. 1956) has made silk-screened Christmas cards annually since 1988. Each year they feature a new and timely whimsical family vignette. His card from 1992, sent to folk art collector Herbert Waide Hemphill Jr., shows Bisese, in striped shirt and cone-shaped hat, and his pregnant wife, who is often pictured with wings and a halo, inside a decorative border of sperm and eggs. Their baby floats upside-down in utero. Bisese used the back of the card as a kind of imprint, placing the date and a significant word or two wrapped around a picture of the artist's beloved Jack Russell terrier, Mr. Harris. In 1992, Mr. Harris, who occasionally was commercially photographed, was on the cover of the Christmas issue of *Baltimore* magazine and hence "more famous" than the year before.

Yasuo Kuniyoshi to Reginald Marsh, 1931
hand-colored print
15 x 9 cm
Reginald Marsh papers, 1897–1955
© 2012 Estate of Yasuo Kuniyoshi/
Licensed by VAGA, New York, NY

Born and raised in Japan, Yasuo Kuniyoshi (1893–1953) moved to the United States in 1906. His depictions of everyday life often reflected his bicultural background. In 1931 he returned to Japan to be with his ailing father and coordinate a few exhibits. From Japan, he sent this card to Reginald Marsh, who was part of his social realist circle. The pink cherubs and symbolic handshake adorning the hand-painted lithograph reveal Kuniyoshi's goal of strengthening Japanese American relations. Kuniyoshi was a member of the Japanese American Committee for Democracy and took an active role in the war effort during World War II.

Carl Schultheiss to Ralph Fabri, undated
intaglio print
17 x 12 cm
Ralph Fabri papers, ca. 1870s–1975

The etchings of Carl Schultheiss (1885–1961) often evoke the pastoral landscapes of Northern Europe, where German-born Schultheiss received a traditional art education and moved to the United States in the 1930s. His classic etching of winged cherubs is reminiscent of Northern Renaissance prints, save for its English greetings of the season.

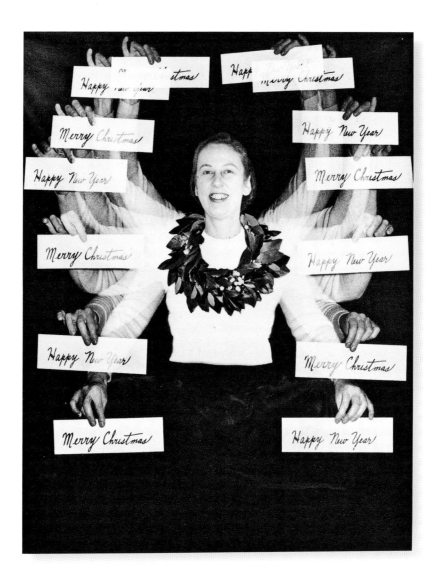

Alexandra Darrow to Prentiss Taylor, 1957
photomechanical reproduction
16 x 13 cm
Prentiss Taylor papers, 1885–1991

Why wish someone a Merry Christmas and Happy New Year just once when you can say it over and over? Darrow met Prentiss Taylor at St. Elizabeths Hospital in Washington, D.C. In 1951, Darrow was a patient at the hospital and Taylor was her art therapist. In her home state of Connecticut, Darrow was the longtime neighbor of Surrealists Yves Tanguy and Kay Sage.

Pablo Cano to Helen Kohen, 1989
watercolor and silver leaf on paper
20 x 15 cm
Helen L. Kohen papers, 1978–1996

As an infant, Pablo Cano (b. 1961) was on the last flight out of Cuba before the Missile Crisis of 1962. Working in the Little Havana neighborhood of Miami, Cano culls through his collection of found material to construct quirky marionettes. His mixed-media card to *Miami Herald* art critic Helen Kohen brings to life the essence of peace.

José Guerrero to Dorothy Miller, 1961
watercolor on paper
13.5 x 18.5 cm
Dorothy C. Miller papers, ca. 1912–1992

Dorothy Miller, curator at the Museum of Modern Art, New York, treasured this holiday card so much that she framed it. The watercolor by Spanish artist José Guerrero (1914–1991) has the same effervescent quality of his massive paintings but fit into Miller's mailbox. In 1950, Guerrero moved from southern Spain to New York City, where he immediately immersed himself in the Abstract Expressionist milieu. In just a few short years, he garnered the attention of not only Miller but also James Johnson Sweeney, then curator at the Solomon R. Guggenheim Museum.

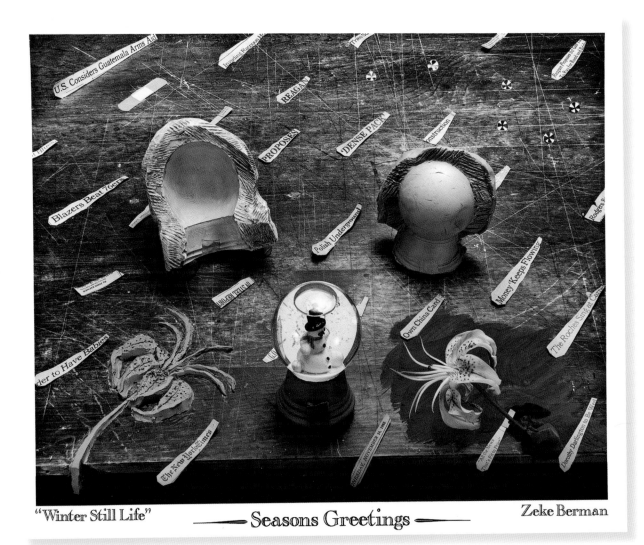

"Winter Still Life" — Seasons Greetings — Zeke Berman

Zeke Berman to Samuel Wagstaff, 1982
photograph
21 x 26 cm
Samuel Wagstaff papers, 1932–1985

Zeke Berman (b. 1951) unconventionally united his divergent backgrounds in photography and sculpture. Many of his photographs are of carefully arranged objects, often of his sculptures. *Winter Still Life*, which he sent to curator and photography collector Samuel Wagstaff, is a thought-provoking display of clippings of newspaper headlines, a snow globe flanked by its positive and negative molds, as well as a lily and its sculptural equivalent.

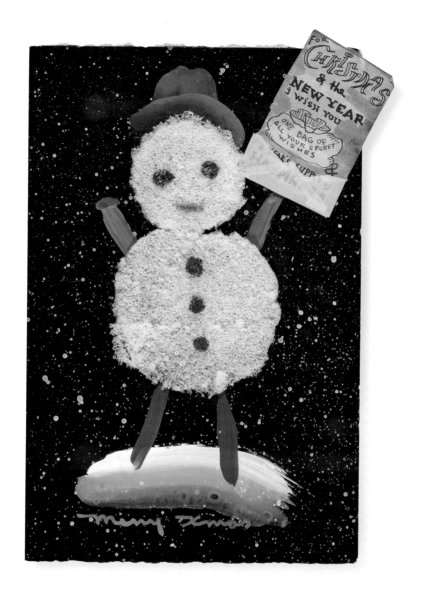

Julia Thecla to Katharine Kuh, undated
mixed media collage
16 x 11 cm
Katharine Kuh papers, 1908–1994

In the 1930s, reclusive artist Julia Thecla (1896–1973) invited curator Katharine Kuh to her small Chicago studio for tea. The "tea" turned out to be whiskey, over which Kuh recalled hearing a peculiar peeping noise that grew louder and louder. Unsure of what was going on, Kuh finally asked Thecla to identify the noise, whereupon Thecla opened the top drawer of her dresser to free her pet chicken. She had stowed it away out of respect to her guest. The collage Thecla made for Kuh, in which a painstakingly composed Styrofoam snowman presents a miniature holiday card, is as memorable as her pet chicken.

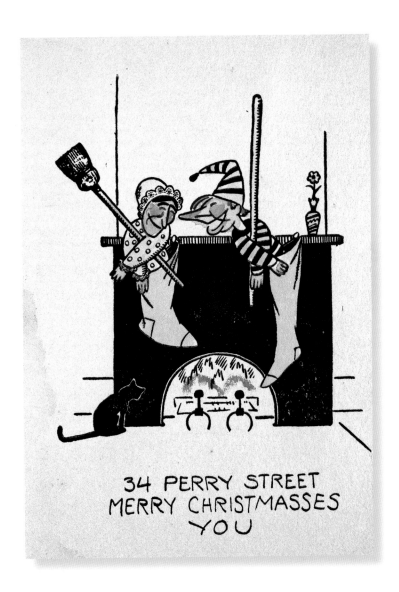

34 PERRY STREET
MERRY CHRISTMASSES
YOU

Alfred Frueh to Wood Gaylor and
Adelaide Lawson Gaylor, 1921
hand-colored print
19 x 29 cm
Wood and Adelaide Lawson Gaylor
papers, 1866–ca. 1986

A cartoon by Alfred Frueh (1880–1968) was published in the debut issue of the *New Yorker* in 1925. Frueh worked for the *New Yorker* for close to four decades until his retirement in 1962. In his annual holiday card, the illustrator always included humorous—if not odd—portrayals of himself and his wife, Giuliette Fanciulli. In their card from 1921, the pajama-clad couple hangs above a cozy fireplace; a bashful Fanciulli shies away from the advances of her leering husband.

Christmas in our Cellar

Greville Rickard

Greville Rickard, unsent, undated
relief print
Greville Rickard papers, 1917–1955

A quaint holiday card by architect Greville Rickard (1889 or 1890–1956) gives a new twist to a favorite poem's opening lines: "'Twas the night before Christmas, when all through the house / Not a creature was stirring, not even a mouse." The family of mice in a dark basement is too busy feasting on Christmas Eve dinner to disturb the tenants upstairs.

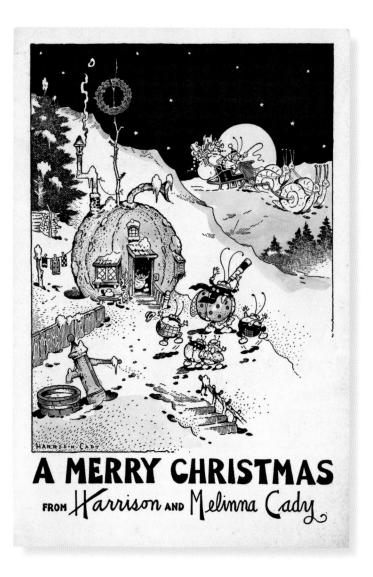

A MERRY CHRISTMAS

FROM *Harrison* AND *Melinna Cady*

Harrison Cady to Eric Hudson, undated
hand-colored print
18 x 12 cm
Eric Hudson and Hudson family papers,
1900–1992

Although Harrison Cady (1877–1970) never received formal art training, he learned on the job when he became a newspaper artist. For more than seventy years, Cady made illustrations for numerous publications, including *Saturday Evening Post* and *Ladies' Home Journal*. Cady's love of the outdoors and his unfettered imagination compelled him to create fantasy villages filled with earthly inhabitants, such as seen in this holiday card in which a ladybug Santa Claus is pulled along by a team of snails.

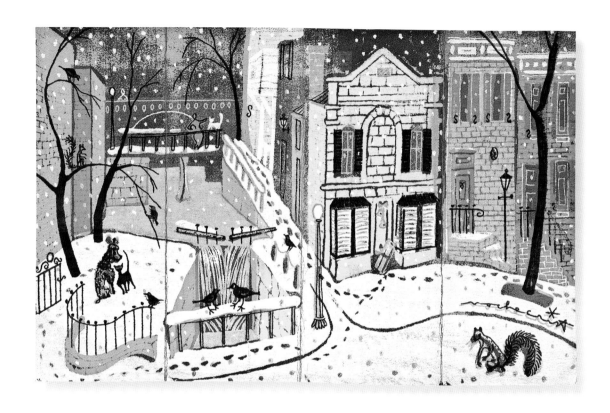

Noche Crist to Prentiss Taylor, ca. 1958
screen print
21 x 35 cm
Prentiss Taylor papers, 1885–1991

Noche Crist (1909–2004) and Prentiss Taylor both lived in Washington, D.C. Many of Crist's works were drawn from her vivid imagination, such as this dreamy silk-screen print of the city's Georgetown neighborhood. A bevy of charming creatures have come out to mingle as the snow falls over the historic C&O Canal.

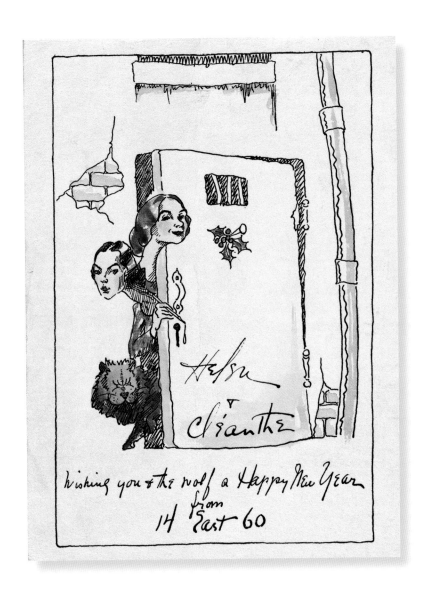

Wishing you & the wolf a Happy New Year from 14 East 60

Cléanthe Carr to Alfred Frueh, ca. 1930
ink and watercolor on paper
17 x 13 cm
Alfred J. Frueh papers, 1904–1993

Peering out from behind the door of their New York City dwelling, Helen Carr, her stepdaughter Cléanthe (1911–2001), and one of their Chow dogs wish Giuliette Fanciulli and her husband, "the wolf" Alfred Frueh, a Happy New Year. The card's creator, Cléanthe, inherited a love of drawing from her father, longtime newspaper and magazine illustrator Gene Carr. Another of her passions was Chow Chow breeding. In 1937, Cléanthe made headlines for staging a wedding between her pedigree Chows, Kubla Khan and Li Helen. She married her two passions by frequently making detailed portraits of Chows.

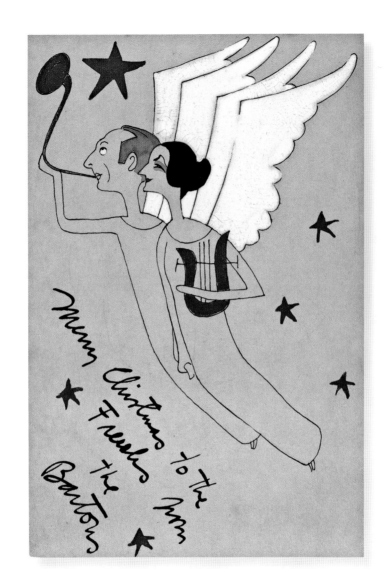

Ralph Barton to Alfred Frueh, ca. 1925
ink and gouache on a print
15 x 10 cm
Alfred J. Frueh papers, 1904–1993

Artists Ralph Barton (1891–1931) and Alfred Frueh, to whom Barton sent this holiday card, frequently caricatured prominent New Yorkers, including Barton's wife, actress Carlotta Monterey, who appeared in films in the 1920s. Many of Barton's portraits are characterized by cynicism and a biting wit, but here he has tenderly portrayed himself and his wife performing an angelic duet.

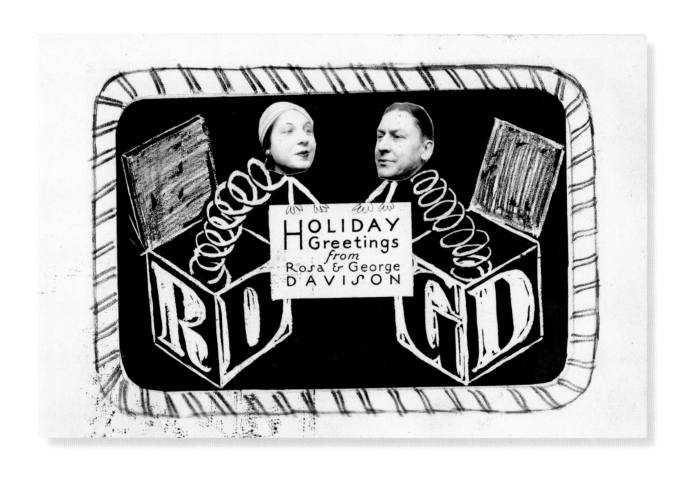

Rosa and George Davison to Fred and
Adelaide Morris Gardner, undated
photomechanical reproduction
9 x 14 cm
Fred and Adelaide Morris Gardner
papers, 1916–1978

Spouses Rosa and George Davison worked together in commercial art in New York City; George ran an art service for the advertising industry, and Rosa often worked alongside him. Their professional savvy about the power of imagery is evident in their eye-catching card to Fred and Adelaide Morris Gardner.

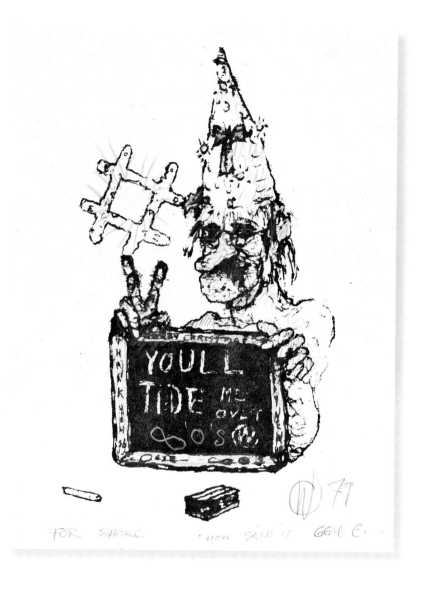

William T. Wiley to Jimmy Jalapeeno,
1979
hand-colored lithograph
28 x 22 cm
Jimmy Jalapeeno papers, 1972–1983

Works by William T. Wiley (b. 1937) always garner a second, if not third, glance. His playfulness with puns constantly changes the meaning of his subjects. In this holiday card to friend Jimmy "Gem E" Jalapeeno, Wiley's alter ego "Mr. Unnatural"—a spoof on R. Crumb's comic character Mr. Natural—has made an appearance. The simultaneously clever and silly sayings of Mr. Unnatural often offer the viewer a new perspective on a seemingly straightforward topic. The chalkboard note "Youll Tide Me Over 80's" can be deciphered as Wiley's unique Yuletide greeting for the new decade.

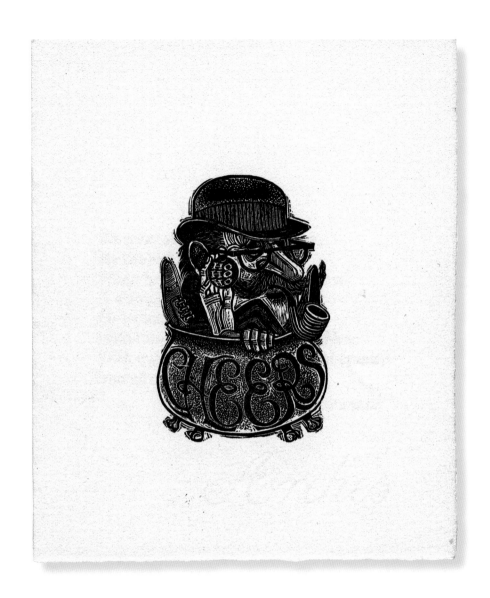

Raymond Gloeckler to James Mullen,
1978
relief print
15 x 13 cm
James Mullen Christmas card
collection, ca. 1955–2003

Raymond Gloeckler (b. 1928) makes very small woodcuts—many are just a few inches wide—that are big on detail. Gloeckler was a professor of art at the University of Wisconsin, where he taught generations of students his techniques in graphic design. Gloeckler exchanged holiday cards with a network of other printmakers, from fellow instructors James Mullen and Warrington Colescott to his former students. The star of his card for 1978 was "Uncle Frank," based on a poem, printed on the card's interior, by Monica Shannon. According to the poem, Uncle Frank "sits and figures in a bank, when he might keep a candy store."

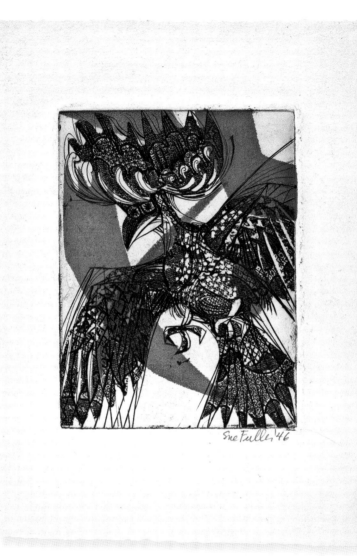

Sue Fuller '46

Sue Fuller to Dorothy Miller, 1946
intaglio print
17 x 13 cm
Dorothy C. Miller papers, ca. 1912–1992

Sue Fuller (1914–2006) used string to help her delineate the patterns of her etchings and engravings. Just a year after she sent this holiday card to Dorothy Miller, string started to become a dominant part of her work. Fuller was soon better known for intricate string sculptures, which share the decorative qualities of her prints.

Helen Gerardia to Prentiss Taylor, 1972
watercolor cutouts and pastel on paper
9 x 21 cm
Prentiss Taylor papers, 1885–1991

Russian American artist Helen Gerardia (1903–1988) carved a niche in the competitive New York art world with her colorful paintings and lithographs. Her compositions often consisted of pure, intense colors cut together to form prismatic arrangements. The cutout of a watercolor painting pasted on her holiday card of 1972 to printmaker Prentiss Taylor suggests a bird.

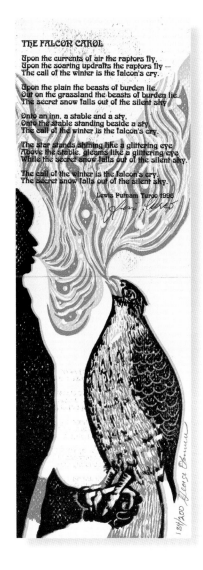

THE FALCON CAROL

Upon the currents of air the raptors fly,
Upon the soaring updrafts the raptors fly —
The call of the winter is the falcon's cry.

Upon the plain the beasts of burden lie,
Out on the grassland the beasts of burden lie.
The secret snow falls out of the silent sky

Onto an inn, a stable and a sty,
Onto the stable standing beside a sty.
The call of the winter is the falcon's cry.

The star stands shining like a glittering eye
Above the stable, gleams like a glittering eye
While the secret snow falls out of the silent sky.

The call of the winter is the falcon's cry.
The secret snow falls out of the silent sky.

Lewis Putnam Turco 1996

Lewis Turco and George O'Connell,
unsent, 1996
relief print
17 x 12 cm
Lewis Turco and George O'Connell
Christmas card collection, 1966–2003

Poet Lewis Turco (b. 1934) and artist George O'Connell (b. 1926) collaborated for decades on an annual "poemprint," a poem by Turco illustrated by O'Connell. In their card for 1996, a fire-breathing falcon and his owner complement Turco's poem, "The Falcon Carol."

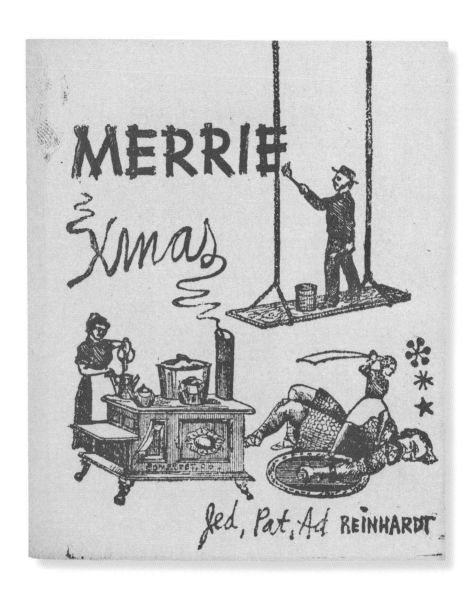

Ad Reinhardt, unsent, ca. 1945
relief print
12.5 x 10.5 cm
Ad Reinhardt papers, 1927–1968

In the 1940s, Ad Reinhardt (1913–1967) illustrated the wildly popular "How to Look at Modern Art in America" series for *PM* newspaper. His biting cartoons defended abstract art, an issue of great importance to Reinhardt because his own minimalist paintings were nonobjective. His holiday card from his *PM* years reflects his incisive sense of humor, as Reinhardt has caricatured each member of his family: Ad as a sign painter; his wife, Pat, toiling away over a stove; and his young son, Jed, slaying Goliath.

V. C. Gibson to Prentiss Taylor, undated
hand-colored print
22 x 14 cm
Prentiss Taylor papers, 1885–1991

Young artist Catherine Gibson started making art in Washington, D.C., in the 1950s but eventually moved to New York City to study at Columbia University. She wrote to Washington printmaker Prentiss Taylor after she settled into an apartment in Greenwich Village. Her unusual holiday card features a Native American pueblo nestled against the the city's skyscrapers.

Marvin Lipofsky to Patti Warashina
and Robert Sperry, 1989
postcard photograph
15 x 10 cm
Patti Warashina papers, ca. 1900–1991

Glass artist Marvin Lipofsky (b. 1938) travels around the globe, and those lucky enough to be on his annual New Year's card list are able to travel vicariously through him. Ceramists Patti Warashina and Robert Sperry received cards from Lipofsky from Jerusalem to the Great Wall of China, each showing, at larger-than-life scale, one of his recent works. In 1989, Lipofsky stopped by Moscow on his way to the First International Blown Glass Symposium in Ukraine. His postcard from that trip shows a piece from the "Soviet Series" he created there.

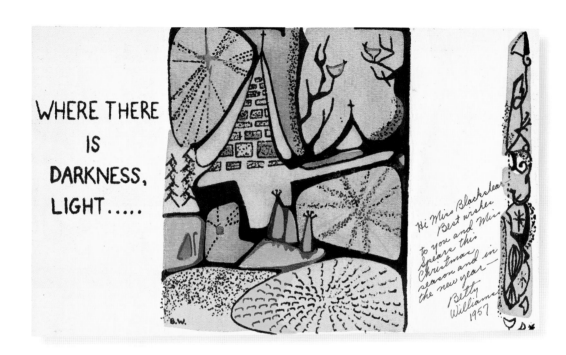

WHERE THERE IS DARKNESS, LIGHT.....

Hi Miss Blackshear,
Best wishes
to you and Miss
Spears this
Christmas
season and in
the new year—
Betty
Williams
1957

Betty Williams Carbol
to Kathleen Blackshear, 1957
lithograph
18 x 30 cm
Kathleen Blackshear and Ethel Spears
papers, 1920–1990

Betty Williams Carbol (b. 1936) studied at the School of the Art Institute of Chicago with Kathleen Blackshear. For many years she mailed intriguing Christmas cards to her former instructor. In this depiction of the nebulously formed Three Kings, she includes a line from the Prayer of Saint Francis.

981 "The Loop", near Newfound Gap in Great Smoky Mountains National Park

7A-H760
PHOTO BY CARLOS C. CAMPBELL, KNOXVILLE

Josef Albers to Marcel Breuer, 1938
acrylic stencil by Albers on a postcard
photograph by Carlos C. Campbell
14 x 9 cm
Marcel Breuer papers, 1920–1986

German-born modernists Josef Albers (1888–1976) and Marcel Breuer were major participants in the Bauhaus, a school that sought to integrate crafts and the fine arts. In the 1930s both artists moved to the United States to escape Nazi Germany. Albers took a teaching position at the progressive Black Mountain College in North Carolina, where he influenced a generation of artists, including Ray Johnson and Robert Rauschenberg. On this postcard of the picturesque Smoky Mountains, Albers fashioned the twisting mountain road into the number "39," thus wishing Breuer a happy 1939.

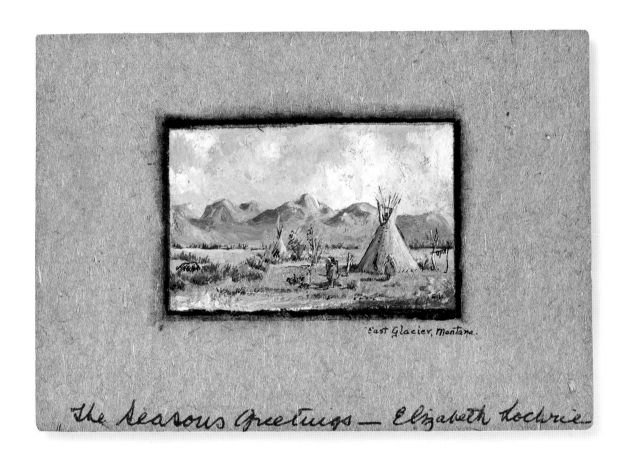

East Glacier, Montana.

The Seasons Greetings — Elizabeth Lochrie

Elizabeth Davey Lochrie
to W. Langdon Kihn, undated
oil on paper
12 x 18 cm
W. Langdon Kihn papers, 1904–1990

When Elizabeth Lochrie (1890–1981) was a girl in Deer Lodge, Montana, she frequently visited her father's Cree friends, many of whom, at the turn of the century, still dwelled in teepees. At the age of nineteen, Lochrie left Montana to study art at the Pratt Institute in Brooklyn. She returned to her native state with a renewed interest in its indigenous people and striking landscape. In 1932 she spent the summer painting at Glacier National Park with Gypsy and George Bull of the Blackfeet tribe. At the end of the season, the tribe adopted Lochrie and bestowed on her the name "Lone Woman." The recipient of this small oil painting was W. Langdon Kihn, who in 1919 had also visited the Blackfeet Indian Reservation on a painting expedition.

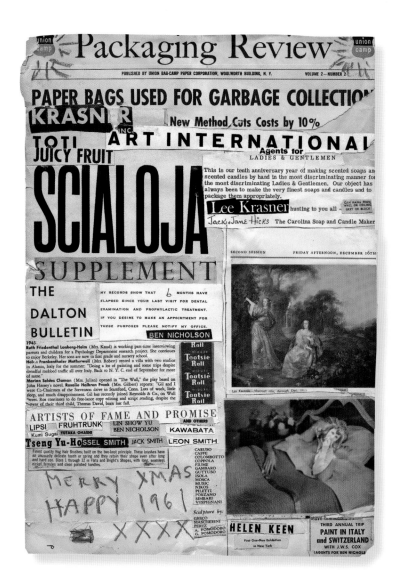

Helen Frankenthaler
to Theodoros Stamos, 1961
collage of clippings and pastel on paper
36.5 x 28 cm
Theodoros Stamos papers, 1922–2007
© 2012 Estate of Helen Frankenthaler/
Artists Rights Society (ARS), New York

In 1947 college student Helen Frankenthaler (1928–2011) critiqued the work of first-generation Abstract Expressionist Theodoros Stamos as part of her summer internship with the short-lived art publication *MKR's Art Outlook*. The article incensed Stamos, especially in that it was written by a nineteen-year-old student. Years later, when Frankenthaler was a promising second-generation Abstract Expressionist, the artists officially met and hit it off. Frankenthaler's large holiday card to Stamos is a departure from her harmonious color-field paintings. Here, she pasted together newspaper clippings and signed her note in pastel.

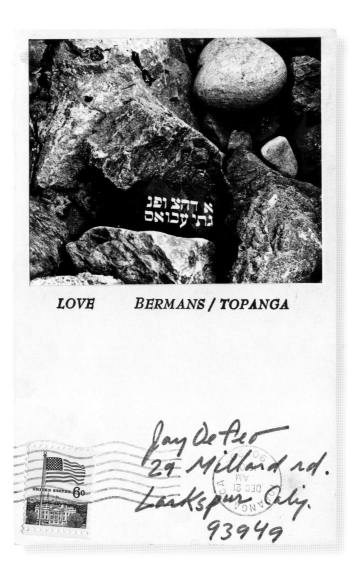

LOVE BERMANS / TOPANGA

Wallace Berman to Jay DeFeo, 1970
ink stamp, marker, and photograph
on paper
16 x 10 cm
Jay DeFeo papers, 1948–1976

Beat Generation artist Wallace Berman (1926–1976) veered off the typical path of an artist, eschewing gallery representation and traditional mediums in favor of mysticism and mail art. From his studio in Topanga, California, he mailed postcard collages to close friends in which randomly arranged Hebrew letters mimic the mystical content of the Kabbalah, an ancient Jewish text that is decipherable only by advanced theologians. Jay DeFeo and Berman, neighbors in San Francisco in the late 1950s, often collaborated on art. One of their projects was a series of intimate photographs of DeFeo layered with Berman's arbitrary assortment of Hebrew letters.

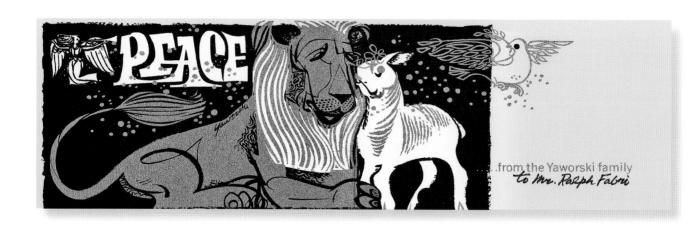

from the Yaworski family
to Mr. Ralph Fabri

Alex Yaworski to Ralph Fabri, ca. 1960
screen print
14 x 40 cm
Ralph Fabri papers, ca. 1870s–1975

Painter Alex Yaworski (1907–1997) designed an annual holiday card for his family and friends. Knowing little about silk-screen printing, he teamed up with Bob Bishop, owner of an advertising and design shop, to produce the cards. Bishop would also print Yaworski's design for himself, to use as his own family's holiday card. Mutual friends of the two men thus received the same card from two different people.

Lambs come in March with the late snows,
When the spirit flags and the wind blows.
Their innocence lingers, pure and mild,
For the bright birthday of the Child.

KATHARINE, JOEL, and E. B. WHITE

Katharine and E. B. White to Alfred Frueh,
ca. 1940
photograph and typeset poem on paper
13 x 13 cm
Alfred J. Frueh papers, 1904–1993

Years before E. B. White (1899–1985) published his now-beloved books *Stuart Little* (1945) and *Charlotte's Web* (1952), he and his wife, Katharine Sargeant Engell (1892–1977), sent this animal-themed holiday card to illustrator Alfred Frueh. Katharine and E. B. met in 1927 while working together at the *New Yorker*, where Katharine was fiction editor and E. B. was newly hired as a contributor. They fell in love and married in 1929, shortly after Katharine divorced her first husband.

Fred and Adelaide Morris Gardner,
unsent, 1941
hand-colored print
14 x 11 cm
Fred and Adelaide Morris Gardner
papers, 1916–1978

Modernist painter Fred Gardner (1880–1952) taught evening art classes at the Brooklyn Evening Technical and Trade School. Enrolled in one of his courses was Adelaide Morris (1898–1974), who would eventually become his wife. The two worked together for many years at the New York City Board of Transportation, where Adelaide was the only female draughtsperson and Gardner was an architectural planner. In 1941 the couple retired and moved upstate to Jamesville, near Syracuse. Their holiday card that year boasted of their new quaint country living and menagerie of farm animals.

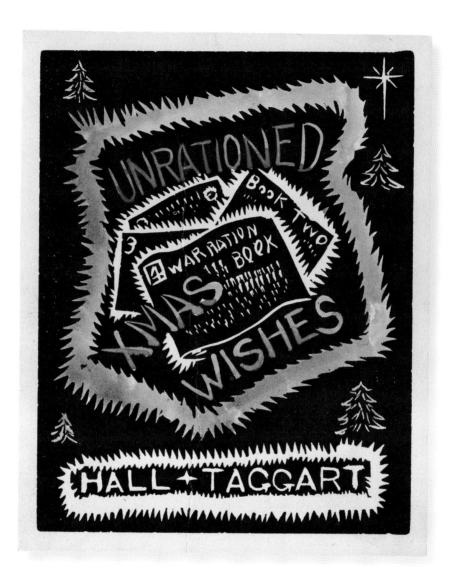

Hall & Taggart to Kathleen Blackshear and
Ethel Spears, ca. 1942
hand-colored print
14 x 12.5 cm
Kathleen Blackshear and
Ethel Spears papers, 1920–1990

During World War II the government put into effect a rationing strategy on items in short supply. War Ration books that held stamps and, later, tokens were required for buying provisions as basic as sugar, meat, and gasoline. The identity of the sender(s) of this card to Kathleen Blackshear and Ethel Spears is unknown, but fortunately their Christmas cheer remained "unrationed" throughout the war.

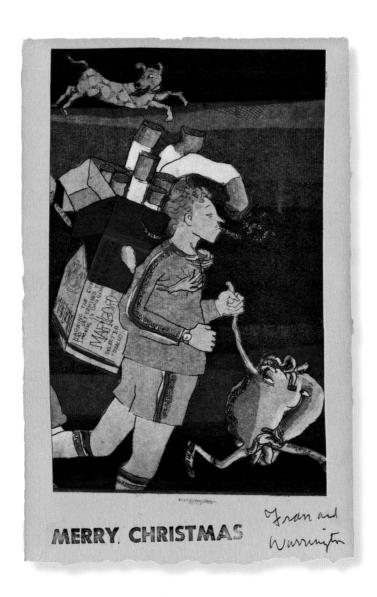

MERRY. CHRISTMAS

Fran and Warrington

Warrington Colescott and
Frances Myers to Raymond Gloeckler,
1980
intaglio print
11 x 14.5 cm
Raymond Gloeckler papers, 1952–2008

Printmaker Warrington Colescott (b. 1921) employs a biting humor to make salient points about politics and society. In his etching *Virtues and Vices* from 1979 (Milwaukee Art Museum, Milwaukee, Wisconsin), Colescott presented a modern take on the ancient pairing: individuals are participating in either healthy activities like bicycling or unhealthy habits like smoking. For a holiday card the following year, Colescott and his wife, printmaker Frances Myers (b. 1938), cut the copper plates of the etching into a smaller portrait of the smoker taking his heart for a jog. For added seasonal flair, they applied red and green glitter details.

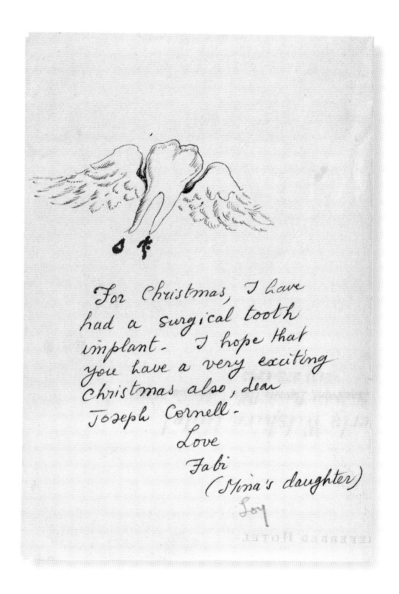

For Christmas, I have
had a surgical tooth
implant. I hope that
you have a very exciting
Christmas also, dear
Joseph Cornell.
 Love
 Fabi
 (Mina's daughter)
 Loy

Fabienne Lloyd to Joseph Cornell, undated
ink on paper
13 x 9 cm
Joseph Cornell papers, 1804–1986

Fabienne Lloyd (1919–1997) was the daughter of Mina Loy and Arthur Cravan, poets steeped in the Dada and Surrealist circles of New York City. Admirers of each other's work, Lloyd and Cornell frequently exchanged playful letters. Fabi sent an illustrated holiday letter to Cornell about her tooth implant, likely assuming that Cornell of all people would enjoy the news along with her sketch of the angelic tooth, as Cornell found delight and inspiration in a range of objects. Cornell created intricate collages and boxes out of material from everyday sources, from Victorian Christmas ornaments to magazine clippings of ballerinas, and more.

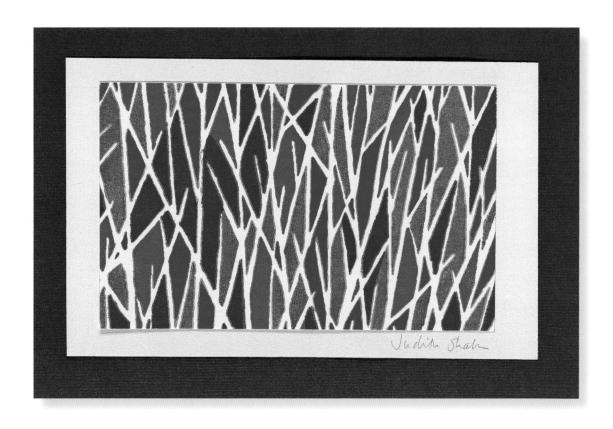

Judith Shahn to Elise Asher
and Stanley Kunitz, 1975
screen print
11 x 14 cm
Elise Asher papers, 1923–1994
© Estate of Judith Shahn

Printmaker Judith Shahn (1929–2009) was the daughter of socially engaged artist Ben Shahn and his first wife, Tillie. Shahn was known for her love of blue. The color dominated her house, her clothing, and her art. Indeed, her screen-printed holiday card of 1975 is a measured arrangement of blue hues. Recipients were poet and artist Elise Asher and her husband, American poet laureate Stanley Kunitz. Judith's own husband, Alan Dugan, was a Pulitzer Prize–winning poet. Both couples were active at Provincetown's Fine Arts Work Center.

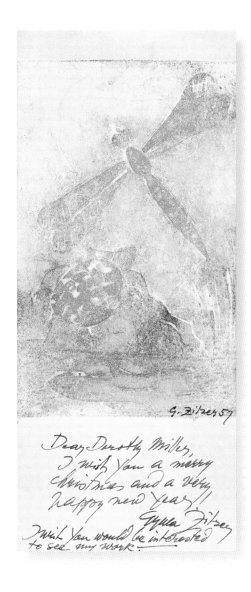

Dear Dorothy Miller,
I wish You a merry
Christmas and a very
Happy new Year!!
Gyula Zilzer
I wish You would be interested
to see my work.

Gyula Zilzer to Dorothy Miller, 1957
intaglio print
23 x 11 cm
Dorothy C. Miller papers, ca. 1912–1992

Hungarian-born painter and lithographer Gyula Zilzer (1898–1969) studied painting and lithography throughout Europe. In 1932 he moved permanently to New York City. That same year, the Jewish artist made one of his first prominent works, a portfolio of lithographs, "Gas Attack," which narrated the application and horrific effects of poisonous gasses on humans. Throughout the Great Depression and World War II, Zilzer conveyed in his art a somber, if not cynical, take on society. The card he sent in 1957 to Dorothy Miller, with its delicate portrayal of a firefly and a turtle, was atypically peaceful for the artist. In addition to conveying holiday greetings, his note to Miller, then curator at the Museum of Modern Art, beseeches her: "I wish you would be interested to see my work."

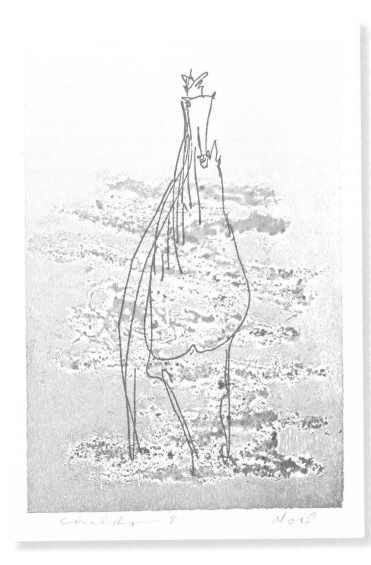

Bernard Childs to Eugenie Gershoy,
1981
letterpress print
15 x 11 cm
Eugenie Gershoy papers, 1914–1983

In 1974, Geoffrey and Maria Kean, who raised polo ponies in Connecticut, commissioned Bernard Childs (1910–1985) to paint their young filly, Rijah. After a trip or two to the Keans's home to draw the pony in her meadow, Childs decided he needed photographs in addition to drawings. On a subsequent visit, he brought along Clara Aich, his photographer. Aich jumped into the meadow and boldly photographed Rijah straight on as the horse galloped. Later, in his studio at New York City's Hotel Chelsea, surrounded by the photographs, Childs captured the animal's surging frontal movement. The result was *Rijah, My Love*, 1974. Childs's 1981 card is based on a pencil study. The recipient was sculptor Eugenie Gershoy, who was Childs's neighbor at the Hotel Chelsea.

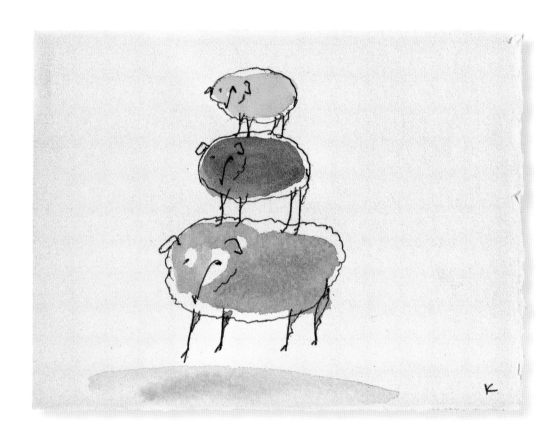

Reiji Kimura to Dorothy Miller, 1966
ink and watercolor on paper
10 x 13 cm
Dorothy C. Miller papers, ca. 1912–1992

In 1965, Museum of Modern Art curator Dorothy Miller co-curated, with William S. Lieberman, a traveling exhibition, "The New Japanese Painting and Sculpture," which highlighted young, contemporary Japanese artists. Among the artists they selected was painter Reiji Kimura (b. 1926). Friendly with Miller, Kimura sent her this watercolor of three sheep stacked on top of one another. On the interior, Kimura wishes Miller a "more beautiful" New Year.

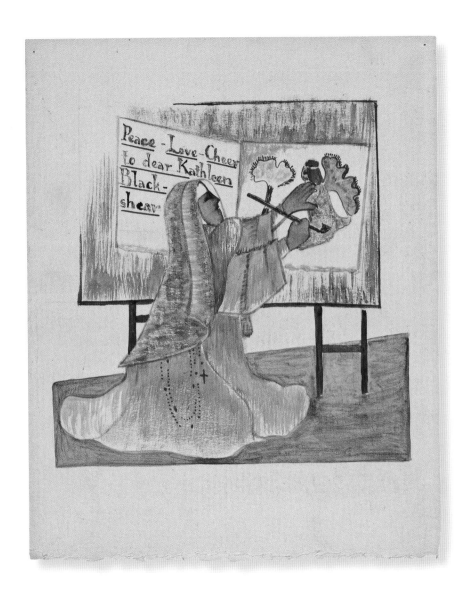

Peace - Love - Cheer
to dear Kathleen
Black-
shear

Sister Mary Aquinas
to Kathleen Blackshear, undated
watercolor on paper
15 x 13 cm
Kathleen Blackshear and
Ethel Spears papers, 1920–1990

Artists Kathleen Blackshear and Ethel Spears befriended numerous nuns, many of whom took courses with Blackshear during her long career as a teacher at the School of the Art Institute of Chicago—some even went on to teach art courses themselves. Showing off her hobby as a painter, Sister Mary Aquinas of the Dominican Order sent this watercolor to Blackshear. The interior includes a hand-lettered quote from the book of Isaiah: "A light shall shine upon us today; for the Lord is born, the Prince of Peace."

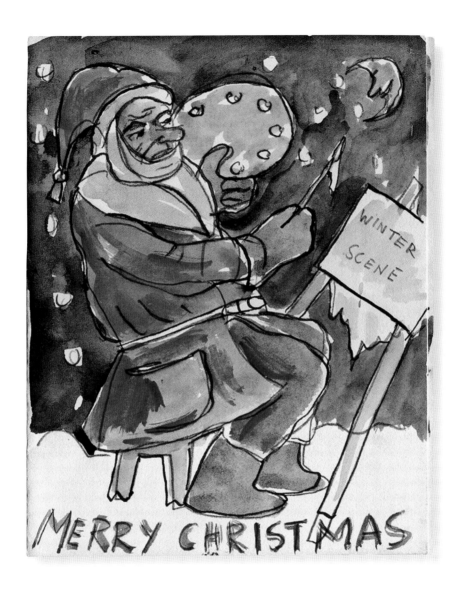

Boris Artzybasheff to Fred and Adelaide Morris Gardner, undated watercolor on paper 13 x 10.5 cm Fred and Adelaide Morris Gardner papers, 1916–1978

Boris Artzybasheff (1899–1965) was best known for his satirical graphic illustrations. In this watercolor painting to fellower New Yorkers Fred and Adelaide Morris Gardner, he has softened his typically hard-edged figures and poked fun at the convention of winter snow scenes.

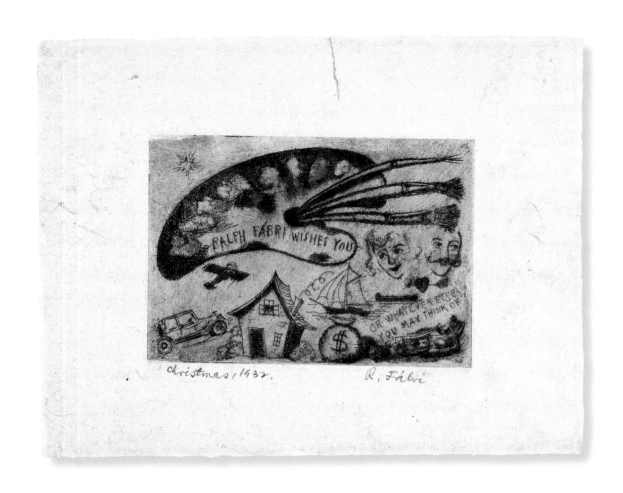

christmas, 1932. R. Fabri

Ralph Fabri to Dale Pontius, 1932
intaglio print
14 x 19 cm
Dale Pontius papers relating
to Ralph Fabri, 1935–1974

Ralph Fabri (1894–1975) was well respected by his peers. In 1942 fellow etcher Irwin Hoffman lauded the Hungarian-born artist: "Among etchers, Fabri is one of the most esteemed artists in the country working in this exacting medium. Technically he is greatly admired for the perfection of his line, the Rembrandt-esque richness of his plates and the great beauty of his form." In his holiday print of 1932, Fabri wishes a medley of Christmas riches for art educator, Dale Pontius.

Irwin Hoffman to Milch Gallery, 1949
intaglio print
17 x 13 cm
Milch Gallery records, 1911–1980

At the young age of nineteen, Irwin Hoffman (1901–1989) was labeled a prodigy in portraiture after a successful solo exhibition in his hometown of Boston. He improved his portraiture skills with studies in Europe and Mexico. Hoffman's holiday card to the Milch Gallery in New York City features a flattering portrayal of his wife, Dorothy, and himself as a Parisian artiste.

Hank Virgona to Mary Gruskin, 1984
watercolor on paper
15 x 22 cm
Midtown Galleries records, 1904–1997

Hank Virgona (b. 1929) once claimed that he chose to be an illustrator because he didn't want to talk to people. His shyness eventually wore off and he became known for his caricatures of public figures. A few decades ago he began making fifty or so holiday cards each year. In 1984, Mary Gruskin and her husband, Alan—the founder of Midtown Galleries—were on Virgona's list. In 2010, when Virgona was eighty-one and his inventory of names had topped more than three hundred people, he stopped making cards.

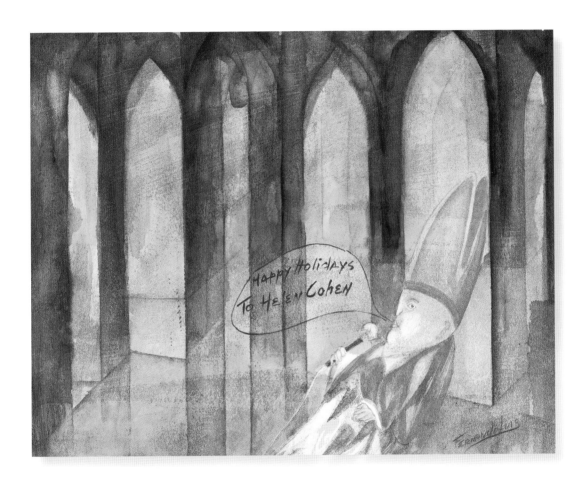

Fernando Luis Dominguez
to Helen Kohen, 1979
watercolor on paper
28 x 22 cm
Helen L. Kohen papers, 1978–1996

Fernando Luis Dominguez (1932–1983) earned acclaim in his native Cuba and abroad with his surreal paintings. Before settling in Miami in 1976, Luis lived in France and Spain. For this card, he painted a Pope posed as a lounge singer crooning holiday greetings to *Miami Herald* editor Helen Kohen.

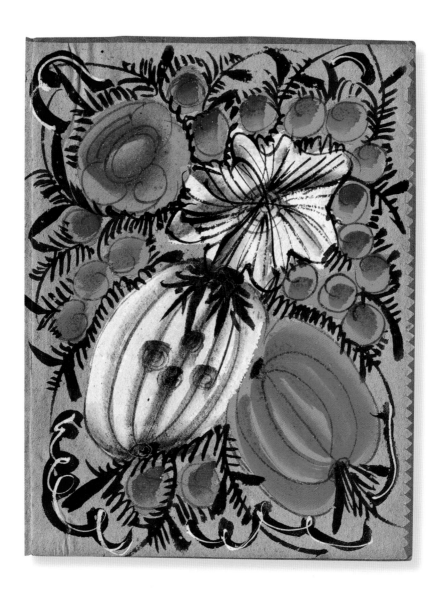

Jane Stabler to Eugenie Gershoy,
ca. 1940
watercolor on paper
15 x 11.5 cm
Eugenie Gershoy papers, 1914–1983

Jane Stabler (1921–2004) was a friend of sculptor Eugenie Gershoy. On the backside of her hot-hued watercolor of a holiday cornucopia, Stabler penned a disheartening triolet:

Star in the window star in the night
I cannot sing a Christmas Carol
I can only pray in the candlelight
Star in the window star in the night

Upon the earth there is blight
Life holds no peace, but only peril
Star in the window star in the night
I cannot sing a Christmas carol

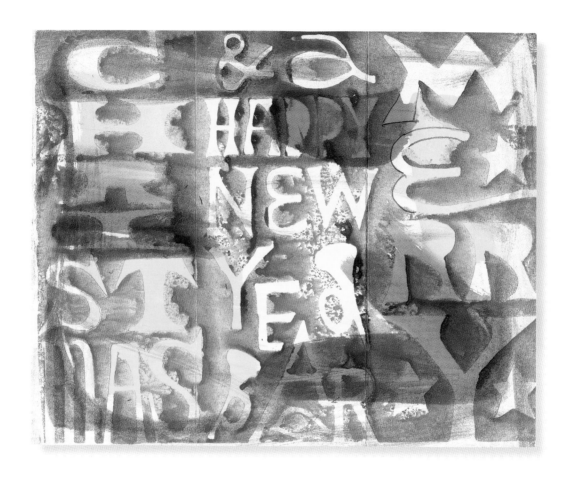

Eduard and Nura Ulreich
to Kathleen Blackshear and Ethel Spears,
1961
watercolor stencil on paper
21.5 x 28 cm
Kathleen Blackshear and
Ethel Spears papers, 1920–1990

As a sign of their unity, Eduard Buk Ulreich (1889–1966) and his wife, Nura Woodson Ulreich (1899–1950), jointly signed their name as "Buk-Nura Ulreich" on their annual holiday card. Together the two pursued many artistic endeavors; Eduard was a muralist, designer, illustrator, and sculptor, and Nura was a children's book illustrator and art instructor. In their card for 1961, they expressed their larger-than-life personalities with an inventive stencil painting of good wishes.

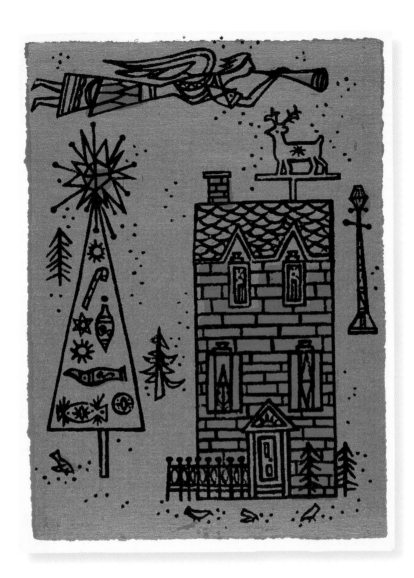

Gordon Kensler to Kathleen Blackshear
and Ethel Spears, 1959
screen print
16 x 12 cm
Kathleen Blackshear and
Ethel Spears papers, 1920–1990

The trumpeting angel on this silk-screen print by Gordon Kensler is the bearer of good news. On the interior of the card the Kenslers announced they were expecting their fourth child in July 1960.

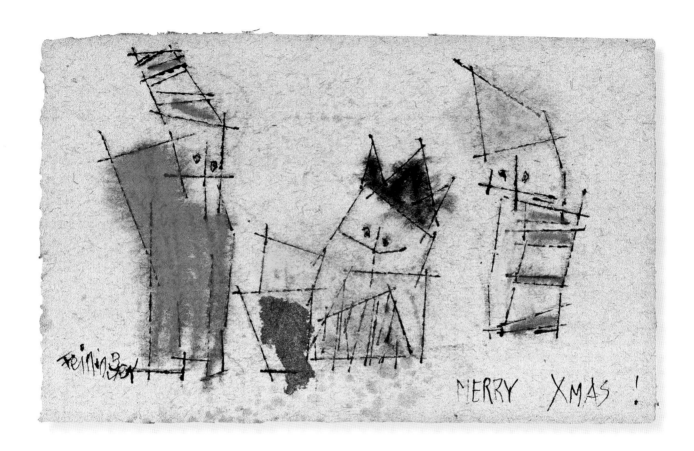

Lyonel Feininger to George Constant,
ca. 1952
ink and watercolor on paper
9 x 15 cm
George Constant papers, 1912–2007
©Artist Rights Society (ARS),
New York/VGBild-Kunst, Bonn

Lyonel Feininger (1891–1956) was born in New York City, moved to Germany as a teenager, then retreated back to New York City during World War II. He was highly regarded in both countries for his Expressionist paintings and drawings, which hovered on the edges of abstraction. This depiction of the Three Kings reflects the sketchy idiom of his drawings.

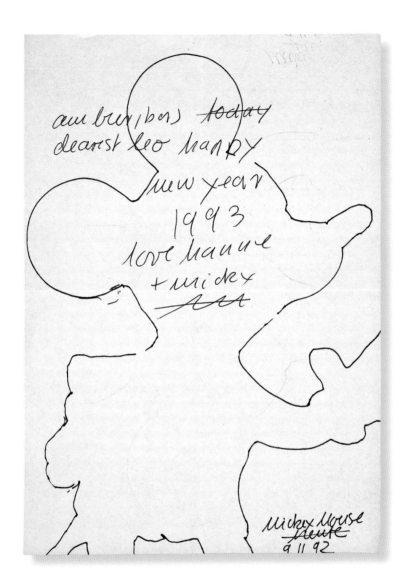

Hanne Darboven to Leo Castelli, 1992
ink on paper
30 x 21 cm
Leo Castelli Gallery records, ca.
1880–2000
© 2012 Estate of Hanne Darboven/
Artists Rights Society (ARS), New York

Hanne Darboven (1941–2009) researched numbered codes, images, and charts to construct her own visual language. She exhibited her massive works on paper in her native Germany and the United States. Darboven's holiday mouse doodle to her New York dealer, Leo Castelli, is more playful than her highly conceptual projects.

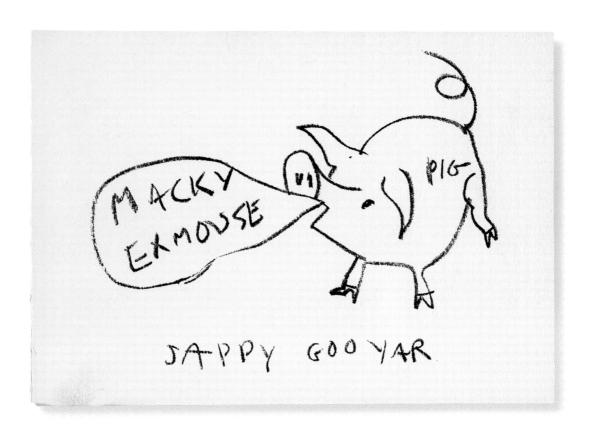

Claes Oldenburg to Samuel Wagstaff,
ca. 1965
photomechanical reproduction
of a drawing
12 x 17 cm
Samuel Wagstaff papers, 1932–1985

Towering public sculptures of otherwise ordinary objects—a paperclip, a slice of pie, and even a shuttlecock—by Claes Oldenburg (b. 1929) are hard to miss. Many of these enormous projects begin with a drawing. When sketching, Oldenburg lets his pencil lead: "When I start a drawing I don't know exactly what is going to happen. I know when it's right, but I don't know how to get there in advance." In a holiday sketch to art curator Samuel Wagstaff, Oldenburg doodled a pig blurting out holiday greetings written in semi-gibberish, perhaps Oldenburg's interpretation of pig Latin.

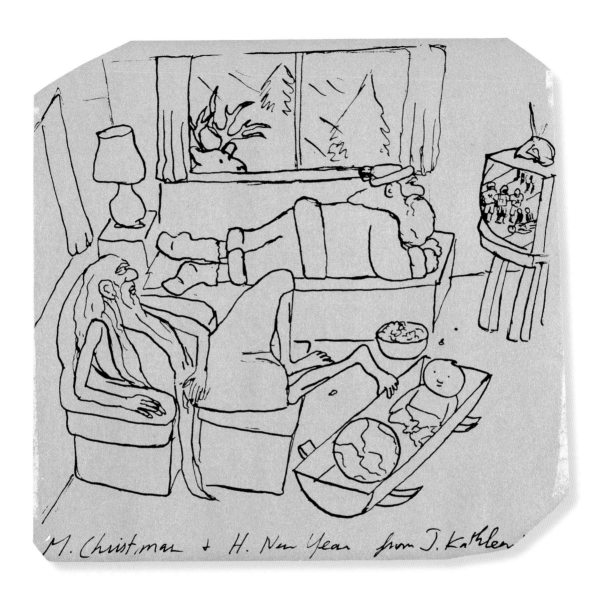

M. Christmas + H. New Year from J. Kathleen

J. Kathleen White
to Ellen Johnson, 1984
photomechanical reproduction of a
drawing
14 x 14 cm
Ellen Hulda Johnson papers, 1939–1980

J. Kathleen White (b. 1952) communicates amusing tales with poems, short stories, and cartoons. Her holiday card to an influential art historian at Oberlin College in Ohio, Ellen Johnson, is a charming vignette showing Santa Claus watching football on television with Old Man Time, who rocks the New Year's Baby in a cradle. Even one of Santa's reindeers tries to sneak a peek at the game.

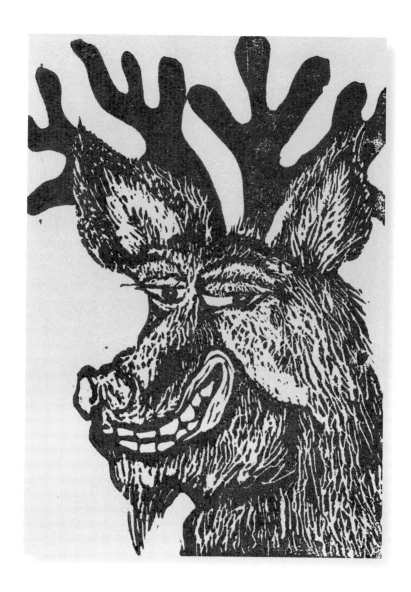

Ann Parker to Raymond Gloeckler,
ca. 1980
relief print
19 x 14 cm
Raymond Gloeckler papers, 1952–2008

Ann Parker (b. 1950), now an elementary school art teacher, artist, and photographer, attended graduate school at the University of Wisconsin and took graphic arts courses with Raymond Gloeckler. A mischievous reindeer commands attention on the front of Parker's holiday card to her former professor.

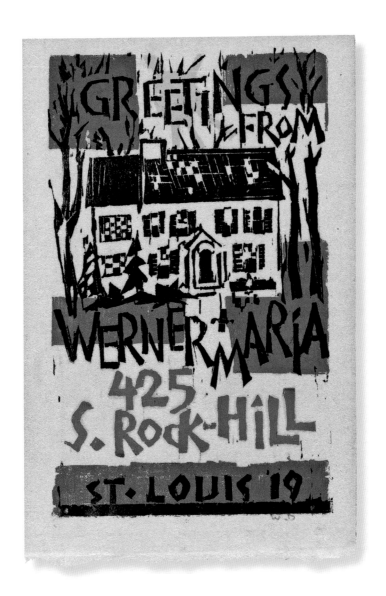

Werner Drewes, unsent, ca. 1965
relief print
23 x 15 cm
Werner Drewes papers, 1924–1984

For Werner Drewes (1899–1985) the road to St. Louis, Missouri, was tumultuous at best. Born in Germany, he studied at the Bauhaus in Weimar in the early 1920s. Like many abstract artists, he left Nazi Germany as it grew critical of nonobjective art. Drewes moved to the United States and taught at the Brooklyn Museum under the New Deal. He eventually moved to St. Louis, where he would teach for twenty years and become widely known for the bold, angular design of his prints, also evident in his numerous holiday cards.

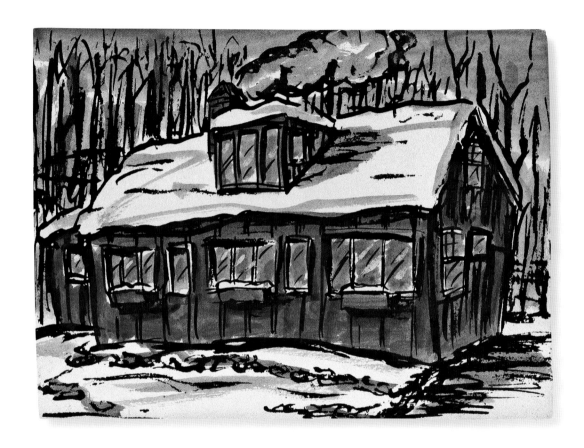

Jana Fay to David Ireland, 1991
watercolor and ink on paper
12 x 17 cm
David Ireland papers, 1936–2009

Sam and Jana Fay were friends of installation artist David Ireland. Here Jana has sent Ireland a cozy picture of the couple's abode in Jefferson, New York. Formerly part of the art-gallery scene, Jana reoriented her career to become a chef. In her note to Ireland in 1991, she commented that she loves the freedom of her new job but misses her old gallery friends.

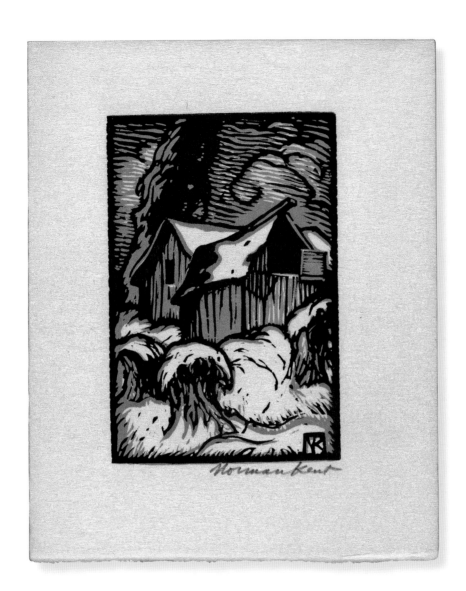

Norman Kent to Ralph Fabri, undated
relief print
16 x 13 cm
Ralph Fabri papers, ca. 1870s–1975

Norman Kent (1903–1972) lived in one of the snowiest places in the country, upstate New York. His woodcut print to fellow illustrator Ralph Fabri does not soften the harsh effects of wintry weather; an ominous winter sky hovers above snow-covered barns and haystacks. Kent was known for his equally striking woodcuts of rural and city life.

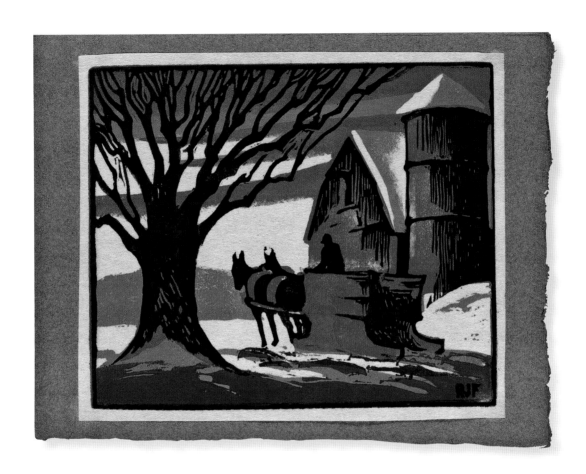

Robert Freiman to Milch Gallery, undated
hand-colored print
12.5 x 17 cm
Milch Gallery records, 1911–1980

Portraitist and landscape painter Robert Freiman (1917–1991) worked predominantly in Boston and Nantucket. Born deaf, Freiman concentrated his efforts on relaying the intensity of his vision to canvas. Whereas other artists might use gray tones to represent a harsh, dismal Northeastern winter, Freiman selected jewel-like hues.

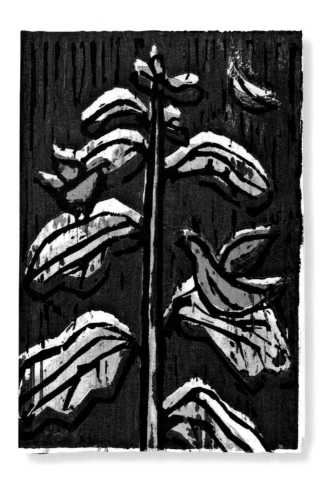

Bobby Donovan to Jacob Kainen, 1994
relief print
19 x 14 cm
Jacob Kainen papers, 1905–2003

Bobby Donovan (b. 1954) was the longtime assistant to artist and curator Jacob Kainen. Donovan considered Kainen to be not just an employer but also a mentor and friend. In his greeting to Kainen, he describes his striking print as "a Christmas card, a New Year's card, and a Thank You card all in one." An artist himself, Donovan seeks to express his connection to the world around him with remarkable color combinations and subjects.

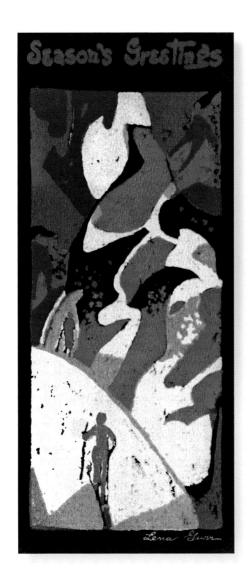

Lena Gurr to Ralph Fabri, undated
screen print
24 x 11 cm
Ralph Fabri papers, ca. 1870s–1975

Jewish artist Lena Gurr (1897–1992) frequently featured secular subjects on her annual holiday card. The Brooklyn artist was known for her kaleidoscopic portrayals of people and places, evident in the screen print of cross-country skiers that she sent to her close friend Ralph Fabri.

Gertrude Abercrombie, unsent,
ca. 1935
relief print
13 x 13 cm
Gertrude Abercrombie papers,
1880–1986

Surrealist painter Gertrude Abercrombie (1909–1977) often enhanced simple Midwestern scenes with eerie effects, although she depicted a wholesome subject for her family's holiday card. In Chicago she was known as the "Queen of Bohemian Artists," and her Hyde Park apartment became the gathering place for artists, including Don Baum, Karl Priebe, and even Dizzy Gillespie.

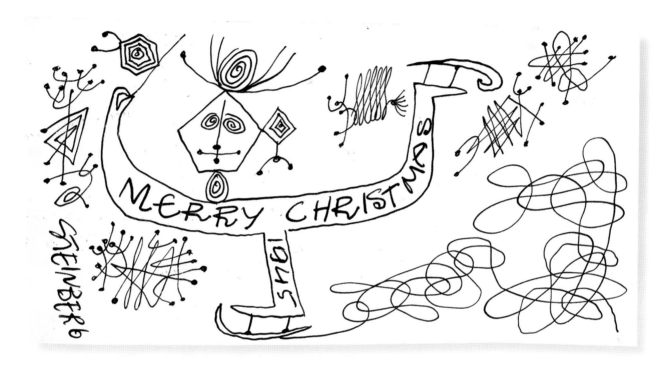

Saul Steinberg to Dorothy Miller, 1945
ink on paper
9 x 18 cm
Dorothy C. Miller papers, ca. 1912–1992
© 2012 The Saul Steinberg Foundation/
Artists Rights Society (ARS), New York

Saul Steinberg (1914–1999) enjoyed success in both the commercial and fine art worlds. His astute drawings were regularly featured in the *New Yorker* and included in museum exhibitions. From 1945 to 1952, he designed holiday cards for the Museum of Modern Art, and the museum's curator, Dorothy Miller, was lucky enough to receive an original ink drawing of an ice-skater, rendered in his distinctive style. Steinberg later tapped into a more lucrative vein of the holiday-card market; in 1952 his designs for Hallmark earned him more money for a single drawing than he would receive for several magazine submissions.

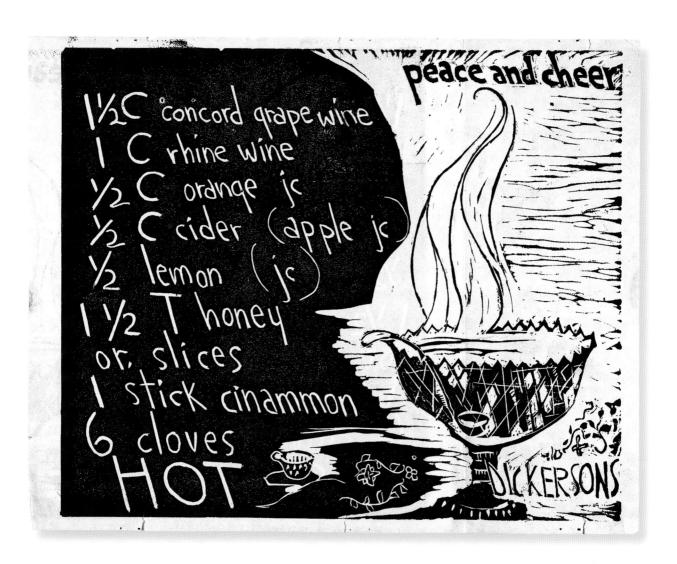

Edward Dickerson to Prentiss Taylor,
1959
relief print
22 x 28 cm
Prentiss Taylor papers, 1885–1991

In 1957 printmaker Prentiss Taylor purchased a work by a young Michigan art student, Edward Dickerson. Dickerson's father, Wendell, was so thrilled that he wrote a personal thank-you note to Taylor, thus beginning an exchange of correspondence between the Dickerson family and Taylor. In one letter Edward likened his studies to the shape of a triangle, noting, "I don't see the top of the triangle from where I stand and I have to continue working my way towards it." He continued to experiment creatively and technically with woodcuts, painting, and apparently, mulled wine.

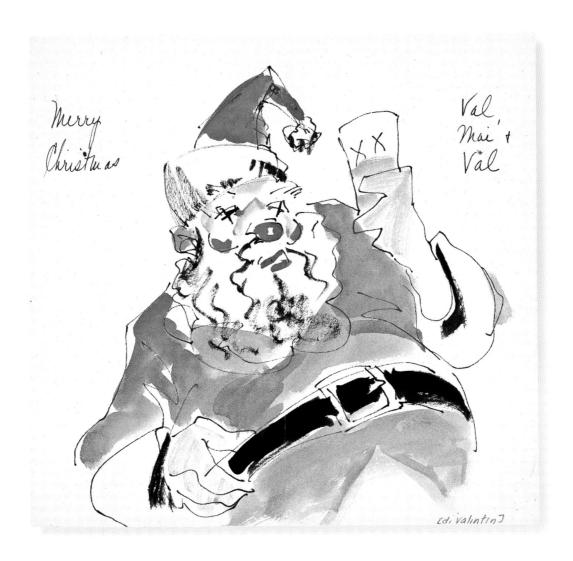

Merry Christmas

Val, Mai & Val

Edi Valentine

Edward Virginius Valentine
to Milch Gallery, ca. 1920
watercolor and ink on paper
19 x 20 cm
Milch Gallery records, 1911–1980

Edward Virginius Valentine (1893–1930) sent this humorous depiction of an off-duty Santa Claus to his dealer, Milch Gallery. It seems that Valentine himself was off-duty when he made this card, as he was better known for his classical sculptures of prominent, even controversial, Americans. A resident of Richmond, Virginia, in the postbellum era, Valentine created public sculptures of Robert E. Lee, Stonewall Jackson, and Thomas Jefferson.

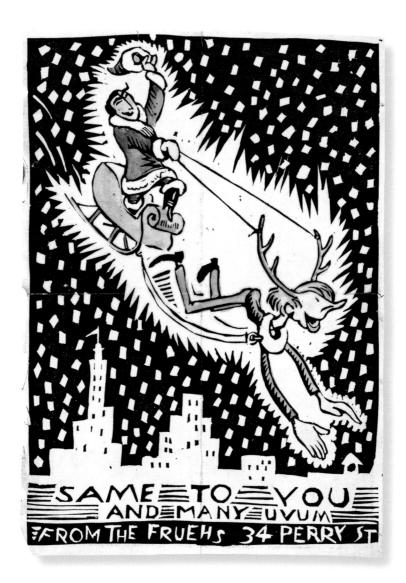

SAME TO YOU
AND MANY UVUM
FROM THE FRUEHS 34 PERRY ST

Alfred Frueh to Wood and
Adelaide Lawson Gaylor, ca. 1920
hand-colored print
28 x 20 cm
Wood and Adelaide Lawson Gaylor
papers, 1866–ca. 1986

Giuliette Fanciulli frequently became a comedic character in annual holiday cards by her husband, Alfred J. Frueh (1880–1968). Here, she is playing the part of Santa, leading her dopey reindeer, Frueh, over the New York City skyline.

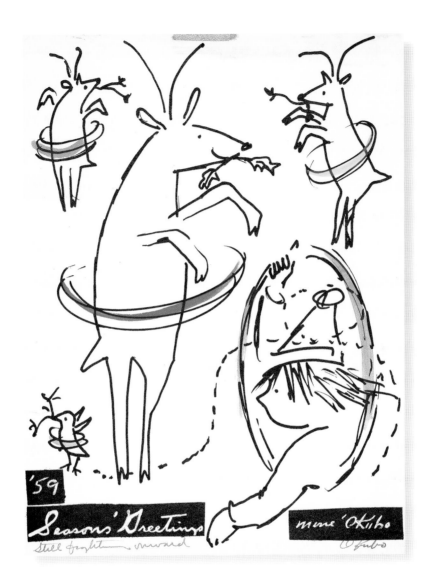

'59

Season's Greetings

Still fighting onward

mine 'Okubo

Okubo

Miné Okubo to Bob Stocksdale and
Kay Sekimachi, 1959
hand-colored print
28 x 22 cm
Bob Stocksdale and Kay Sekimachi papers,
1937–2004

Miné Okubo (1912–2001) wrote and illustrated *Citizen 13660* (1946), a compelling narrative of life inside Japanese internment camps during World War II. While at the Central Utah Relocation Center (Topaz) in Millard County, she taught art and frequently sketched the day-to-day happenings. Likewise, Kay Sekimachi, the recipient of many of Okubo's lighthearted holiday cards, was incarcerated at the Tanforan Relocation Center in San Bruno, California, where she took arts and crafts classes. Sekimachi later became a pioneering fiber artist and together with her husband, Bob Stocksdale, a woodturner, social and political activists in Berkeley.

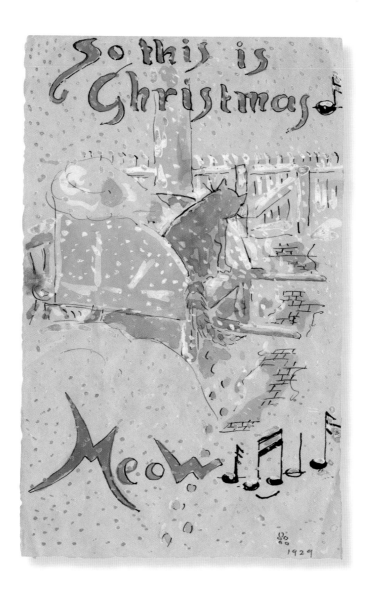

Ida Proper to Julie Hudson, 1929
watercolor, ink, and gouache on paper
15 x 10 cm
Eric Hudson and Hudson family papers,
1900–1992

Ida Proper's work was often noted by critics for its expressiveness, but her activism was perhaps her most expressive outlet. Proper (1873–1957) was part of a circle of woman artists that in 1915 used art to advocate for the women's suffrage movement. The ambitious Proper opened a gallery with Malvina Hoffman and became art editor of the *Women Voter*. Proper's holiday watercolor to fellow artist-activist Julie Hudson features her curious yellow tabby, Topaz.

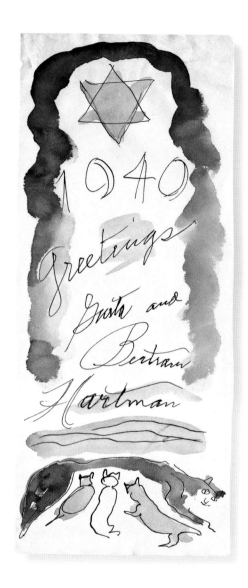

Bertram Hartman to Fred and
Adelaide Morris Gardner, 1940
watercolor and ink on paper
21.5 x 9.5 cm
Fred and Adelaide Morris Gardner papers,
1916–1978

Bertram Hartman (1882–1960), a painter of idyllic landscapes, met his future wife, Gusta, a rug maker,
in Paris's artsy Latin Quarter in 1924. While vacationing at the Hotel Taube in Austria during the winter of 1925,
they befriended writer Ernest Hemingway, who took an interest in Gusta's capricious life and even began a
short story about it. For the couple's holiday card of 1940, Bertram illustrates their shared devotion to cats and,
with a Star of David, Gusta's Jewish background.

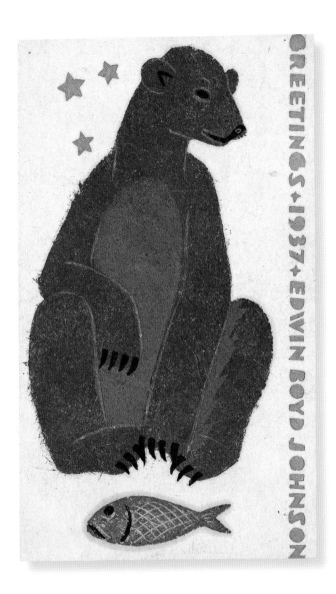

Edwin Boyd Johnson
to Kathleen Blackshear, 1937
Silkscreen print
14 x 40 cm
Kathleen Blackshear and
Ethel Spears papers, 1920–1990

In 1937 the Federal Art Project sent painter Edwin Boyd Johnson (1904–?) to Alaska to paint its vast wilderness. A native of Chicago, Johnson sent this holiday card to School of the Art Institute of Chicago instructor Kathleen Blackshear as a souvenir of his trip to the final frontier.

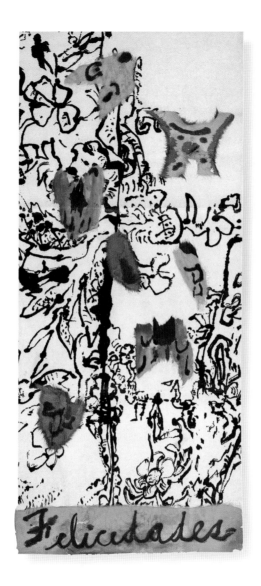

Margaret Stark to Dorothy Miller, 1964
ink on handmade paper
36 x 16.5 cm
Dorothy C. Miller papers, ca. 1912–1992

The work of Margaret Stark (1915–1998) often reflects her explorative journey in paint and paper. She probes and plays with materials to fashion dynamic, abstracted works. Stark's holiday card to Dorothy Miller was no exception. On the back of the collage, she wrote, "This started out to be a Spanish Xmas tree and ended up as a butterfly bush so I decided that the person who would understand THAT would be you. Love and Merry everything from both Walter and Margaret." At the time, Stark was married to famed violist Walter Trampler.

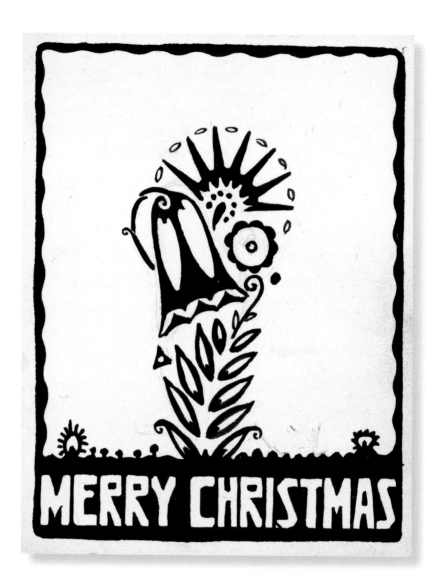

Rudolph Schaeffer, unsent, ca. 1935
ink on paper
11 x 8 cm
Rudolph Schaeffer papers, 1880s–1994

Founder of the Rudolph Schaeffer School of Design in San Francisco, Rudolph Schaeffer (1886–1988) put to practice his theories on design and nature, resulting in this striking holiday card. Schaeffer's side interests included flower arrangement and theory. In 1935 he published an early book on the subject, *Flower Arrangement*.

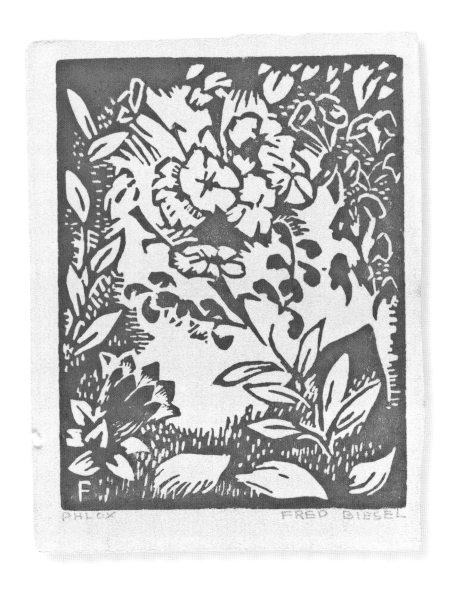

Fred Biesel to Dorothy Miller, ca. 1945
relief print
15 x 12 cm
Dorothy C. Miller papers, ca. 1912–1992

Fred Biesel (1893–1954) and his father, Charles, were part of "The Ten," an artistic circle in Chicago recognized for its members' decorative portrayal of nature. Biesel's works were often lauded by conservative *Chicago Tribune* critic Eleanor Jewett for their charming subjects such as vibrant landscapes and floral motifs. His midcentury holiday card is a woodblock print of a phlox, a popular perennial in the Midwest.

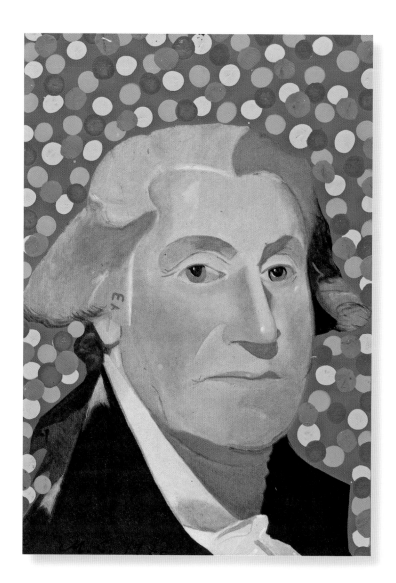

George Washington
1974, oil on canvas, 20 x 28 inches
Michael Clark, American, b. 1946
The Everson Museum of Art
Syracuse, New York 13202

XII – 1977

Dear Ruth & Jacob,

Seasons Greetings!

Happy 1978 New

Year!

Love

Pamela & Michael

Printed by *MUSEUM PRESS, INC. Washington, D. C.*

Ruth & Jacob Kainen
27 W. Irving Street
Chevy Chase, Maryland

Clark V. Fox to Ruth and
Jacob Kainen, 1977
paint on postcard
15 x 11 cm
Jacob Kainen papers, 1905–2003

Painter Clark V. Fox (b. 1946) often manipulates iconic American images, from John F. Kennedy to Mr. Peanut, to encourage viewers think critically about the association between American culture and capitalism. Fox's complex holiday card from 1977 can be understood in layers: he painted cheery dots on top of a postcard of one of his works, *George Washington* of 1974 (The Everson Museum of Art, Syracuse, New York), which itself appropriates one of Gilbert Stuart's many paintings of the first president. One of Stuart's iconic depictions of the first president is now visible on the one dollar bill. When Fox sent this holiday card to painter Jacob Kainen and his wife, he went by his birth name, Michael Clarke.

Frank Vavruska to Dorothy Miller,
1959
hand-colored relief print
9 x 11 cm
Dorothy C. Miller papers,
ca. 1912–1992

Frank Vavruska (1917–1974) was a nomadic artist. Born in Wisconsin, he studied art at the School of the Art Institute of Chicago, where he was awarded a traveling scholarship to Mexico, a journey that kick-started his wanderlust. Vavruska served in the army during World War II and was hospitalized for a time in England. After the war, he traveled extensively through Europe, North Africa, and the Yucatán Peninsula. Vavruska's fascination with Mayan archaeological sites in the Yucatán inspired his art, as seen in his holiday woodblock print of 1959 that echoes the culture's ancient motifs.

Marilyn Brownell to James Mullen, 1974
relief print
12.5 x 17.5 cm
James Mullen Christmas card collection,
ca. 1955–2003

When art instructor James Mullen reminisced about his former student Marilyn Brownell, he noted that she had a cynical but lighthearted sense of humor. The sentiment of her woodcut print from 1974 is likely shared by those who agree with Brownell's comic view of the holiday season. After studying with Mullen at the State University of New York at Oneonta, Brownell exhibited her work in Albany, New York.

Howard Mandel to Ralph Fabri, 1973
screen print
16 x 23 cm
Ralph Fabri papers, ca. 1870s–1975
© Howard Mandel/
Licensed by VAGA, New York, NY

In the "Christmas Surprise Show" exhibition at the Ganso Gallery in New York City in the 1950s, the big draw was a painting of Santa Claus by Howard "Tiffany" Mandel (1917–1999). "Tiffany" was a tongue-in-cheek nickname bestowed on the artist in the exhibition brochure as a nod to his numerous awards, including the prestigious Louis Comfort Tiffany Prize for promising young artists. Mandel's thoughtfully articulated planar arrangements and color harmonies often caught the attention of award panels as well as critics and fellow artists.

Andrew Bucci to Prentiss Taylor, 1964
watercolor and colored pencil on paper
16 x 12 cm
Prentiss Taylor papers, 1885–1991

Andrew Bucci (b. 1922) was a meteorologist at the National Meteorological Center in Maryland from 1956 until his retirement in 1979. Though he worked as a scientist by day, Bucci is also an artist whose abstract paintings exhibit the sprightly character of this colorful greeting.

ACKNOWLEDGMENTS

I THANK THE ENTIRE STAFF of the Archives of American Art for their enthusiasm and patience during this project. When I first mentioned my love of holiday cards to Acting Director, Dr. Liza Kirwin, she immediately suggested I write a book on them. I thank Liza for her initial and continued support of this book. I especially want to thank our scrupulous registrar, Susan Cary, for being my fellow holiday-card enthusiast and co-curator of our holiday-card exhibition. Also at the Archives, Marv Hoffmeier digitized more than three hundred cards, Bettina Smith catalogued essential details about them, and Wendy Hurlock-Baker played an integral role in handling rights and reproduction issues. The dream team at Smithsonian Books, Carolyn Gleason, Matt Litts, and Christina Wiginton shaped this book into a reality that surpassed all of my expectations. Editor Jane McAllister did a tremendous job of reviewing the manuscript and making perceptive suggestions. The brilliant design work by Bill Anton excelled in making the creative cards in this book look even better.

I could not have found all of these holiday cards on my own. Many of my colleagues— Barbara Aikens, Elizabeth Botten, Jenifer Dismukes, Charles Duncan, Jean Fitzgerald, Sara Haug, Jayna Josefson, Erin Kinhart, Judy Ng, Jason Stieber, and Karen Weiss— frequently shared their discoveries of handmade holiday cards with me. Likewise, Archives volunteer Cintia Lombardi and interns Delia Murphy, Meaghan Olwell, and Leah Rand reviewed countless collections in search of remarkable cards. As I wrote captions for this book, interns Marion Carr and Jennifer Strotz conducted extensive research, sleuthing out intriguing anecdotes and facts.

Many artists shared personal insights into their cards, and family members and art historians provided intriguing details about the artists. To this end, I thank Peter Bardazzi, Judith Childs, Warrington Colescott, Michelle Elligot, Heidi Everhart, Ray Gloeckler, Nancy Holt, Ward Jenkins, Thomas Lanigan-Schmidt, Mimi Levitt, Kathleen Mangan, David Manzur, Musa Mayer, Joann Moser, Christopher and Kirk Mueller, James Mullen, Peter Neumann, Prudence Peiffer, Susan and Buddy Rhodes, Mie Sato, Carolee Schneemann, Ezra Shahn, Patrick Walsey, Daisy Wang, Menachem Wecker, and Don Yaworski.

ARTIST INDEX